IMAGES
of America
YORKVILLE

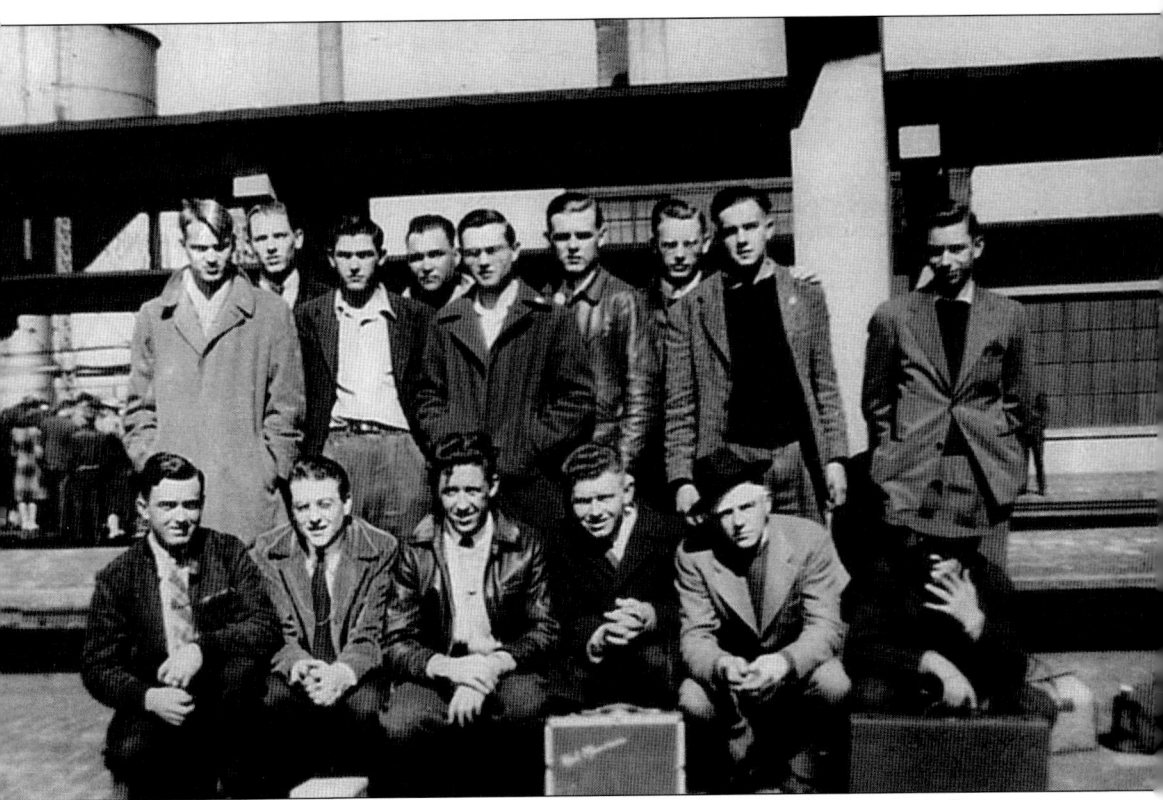

Recruits pose for a photograph near the Yorkville train station in 1943 before leaving for basic training during World War II. Nick Scull, 19, is standing third from the left. (Courtesy of Jeff Scull.)

ON THE COVER: Downtown Yorkville bustled on Saturdays, as farmers and their families came to town to visit, shop for groceries, and conduct other business. This picture postcard from about 1910 with a view facing north shows the west side of Bridge Street. Nina Ament is shown wearing a coat on the far left side of the group of ladies. (Courtesy of Thomas Milschewski.)

IMAGES of America
YORKVILLE

Jillian Duchnowski
Foreword by Howard Manthei

Copyright © 2014 by Jillian Duchnowski
ISBN 978-1-4671-1311-3

Published by Arcadia Publishing
Charleston, South Carolina

Printed in the United States of America

Library of Congress Control Number: 2014941809

For all general information, please contact Arcadia Publishing:
Telephone 843-853-2070
Fax 843-853-0044
E-mail sales@arcadiapublishing.com
For customer service and orders:
Toll-Free 1-888-313-2665

Visit us on the Internet at www.arcadiapublishing.com

*To the future caretakers of the Chapel on the Green;
may you always find wonder in its rich history*

Contents

Foreword	6
Acknowledgments	7
Introduction	8
1. Two Towns Divided by a River	11
2. Growing Commerce and Community	29
3. Yorkville at Work and Play	51
4. Pushing for Progress	81
5. A New United City of Yorkville	101
Bibliography	127

Foreword

It has been a real pleasure assisting in the assembling of information and photographs for this publication. Many members of our organization, the Chapel on the Green Historical Society, have ties not only to our chapel building but also to Kendall County. Some of them are descendants of the county's original settlers. So it came as no surprise that so many came forward with the wonderful photographs that you see in this publication.

The Chapel on the Green church building will celebrate its 160th anniversary in 2015. It was first dedicated in 1855. Although the church went through various periods of change and mergers over time, the building is still being used for religious ceremonies—mostly weddings. As a nonprofit organization, our sole goal today is the preservation of the building. As with the original church, it is still being used for a variety of community activities and cultural events.

With so many residents new to Yorkville since the population influx of recent years, it is our hope that you will become familiar with places that do not exist anymore, including the Y-Mart, Safari, and Countryside Center, to name a few, places near and dear to many old-time residents. The bustling downtown of days gone by is displayed here with some wonderful photographs.

An unexpected treat for me was when, early in the process of collecting photographs, a group of residents visited the chapel with a collection of fascinating photographs to share. The comradeship that emerged that Saturday morning was delightful, as the stories and recollections started filling the room with genuine excitement. It is my hope that you to will share that excitement as you explore this history book.

—Howard Manthei
Executive Director
Chapel on the Green Historical Society

Acknowledgments

When I began this project, I hoped it would both reflect Yorkville and benefit Yorkville. Not only has it done that, but it has also become a project truly created by Yorkville.

It would be impossible to mention everyone here who has breathed life into this book, but I would be remiss if I did not thank Howard Manthei, Susan Kritzberg and the rest of the Chapel on the Green Historical Society, a nonprofit organization, for their early and continued support. Their love of Yorkville is evident in most things they do. Roger Weiss Jr. was generous with his extensive collection of photographs and memories, and Thomas Milschewski provided much youthful enthusiasm and a reminder that history lives in the young, as well as the old, er, more experienced.

Several others paved the way: Rev. Edmund Warne Hicks, who wrote a history of Kendall County published in 1877; Kathy Farren, the *Kendall County Record* editor who coauthored a history of Yorkville in 1986; and the Yorkville Public Library, whose genealogy room and oral history project of 2011 both proved invaluable.

I also wish to thank my acquisitions editor at Arcadia Publishing, Maggie Bullwinkel, whose experience and guidance provided much polish to these pages. Finally, I owe a debt of gratitude to my parents, Kim and Len Duchnowski, who still believe (and remind me) that I can accomplish anything once I set my mind on it; to Renee Messacar, Rob Gryder, and Jen Slepicka, whose friendship makes most endeavors seem like adventures; and to Rob Carroll, whose love and support is helping me see the world through his eyes as well as my own.

INTRODUCTION

"Reining up their horses on the present Court House Hill, they gazed on the lovely stream below them, the wide beautiful prairies beyond them, and the timber behind them. The green was dotted with flowers, the birds sang in the branches, and a group of deer stood gazing at strangers from the edge of a hazel thicket some distance away. 'Here,' thought Mr. Adams, 'is my home,' and dismounting he drove his stake in the soil and took possession."

That is how Rev. Edmund Warne Hicks, in his 1877 history book, describes Earl Adams's first experience with what would become Yorkville. Adams's home, less than 200 years later, would be home to more than 17,000 people, many trying to cope with the financial roller coaster of purchasing new-construction homes just as the housing bubble was bursting. The river not too far below him would attract fishermen from the Chicago area but would also claim more than two dozen lives before state officials started reconstructing the Fox River dam in 2006 to alleviate the underwater churn responsible for several drownings. The wide, beautiful prairies would support farms for many, many decades before housing and commerce spread far past the town's only bridge over the Fox River.

Adams built a log cabin in 1833 on the prominent hill near what was eventually the intersection of Madison and Main Streets, only to sell it a year later to the Bristol brothers, Lyman and Burr, who owned property north of the Fox River. Rulief Duryea laid out the village of Yorkville in 1836 south of the Fox River, about three years after the Bristol brothers named the village they laid out north of the river after themselves, according to *A History of Yorkville, Illinois 1836–1986*, by Lucinda Tio and Kathy Farren. The two villages would share a school district, but would not combine into one city until 1957. In the decades leading up to the unification, residents would pass town population signs in the middle of the Fox River bridge, indicating they were entering a new jurisdiction.

A business community grew much faster than the United City of Yorkville, though. John Schneider built a mill at the mouth of Blackberry Creek in 1834, and E.A. Black, who moved to the area in 1846, opened a paper mill with six waterwheels, which he stopped running at the end of 1876, according to Reverend Hicks. The Kendall County Courthouse was built in 1864 on the hill Adams had lauded, and, four years later, Manzo Lane replaced the Yorkville dam, which a spring freshet had destroyed. Then, Lane built the first bridge connecting Bristol and Yorkville across the Fox River. German immigrant Justus Nading opened a bakery and store in 1884, and the electric plant opened on November 5, 1898. Before long, the ice companies were sawing blocks of ice out of the Fox River, and housewives would request delivery of 25, 50, 75, or 100 pounds of ice in the summer, according to Tio and Farren. John R. Marshall, then 27, founded the *Kendall County Record* in May 1864.

Yorkville's education system was becoming more formalized around this time, too. Two grade school districts, located on either side of the river, combined in 1882 into Yorkville High School, which opened on September 1, 1883, in an upper room of a building in downtown Yorkville, as

superintendent F.C. Thomas writes in "Facts About Kendall County Schools," published in the late 1930s. In 1887, the central section of the current Parkview Christian Academy was built, and, in 1920, several rural districts consolidated with the district so that all were overseen by one superintendent. By 1935, Yorkville Consolidated High School's enrollment was 214 students.

The library's development was a little slower. It started in December 1871, when the Union Library Association was organized at the community's first bank, the Kendall County Bank, according to a library history written by longtime Yorkville librarian Mary Faith Thomas. The small library had about 200 books, and it moved to the Women's Christian Temperance Union Reading Room, which was built in 1878 as a small, 22-foot-by-40-foot wooden building near the southeast corner of Bridge and Van Emmon Streets. The reading room, aside from library activities, also hosted an oyster supper, a larceny case (because of a "bad atmosphere pervading the Court"), a public debate on immigration, Easter sociables, and, starting in October 1911, meetings of the Yorkville Woman's Club. In December 1915, the Woman's Club opened a public library and reading room that was staffed by volunteers until the library was turned over to the United City of Yorkville in 1965. Ultimately, the original reading room was sold to make room for the Yorkville National Bank to expand, and the library moved to a new location down the street.

Just as the Fox River continued to flow through the center of the community, commerce and education kept streaming onward. The Kendall County Farm Bureau had about 1,000 members when it opened in June 1920, and, for a period, the Ohse family operated two grocery stores downtown. English immigrants Edward and Edith Allen ran the aptly named Allen's Restaurant for decades at the northwest corner of Bridge and Van Emmon Streets. Yorkville Grade School was built in 1952, a new high school opened next door in 1959, and Circle Center School opened in 1967. The Model Box factory opened a couple blocks off the downtown business district in 1950. The Countryside Center opened on the northwest corner of Routes 34 and 47 in 1972, the same year the Fox Industrial Park opened on the south side of Yorkville.

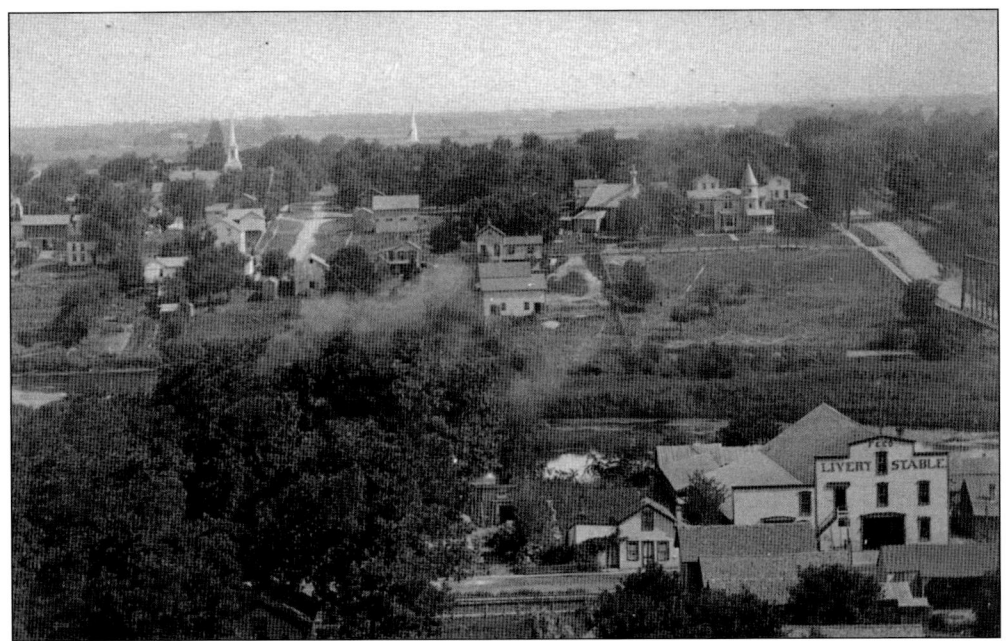

The view in this undated photograph looks north, showing Yorkville, south of the Fox River, and Bristol, north of the water. Bridge Street is seen at the far right. (Courtesy of the Little White School Museum.)

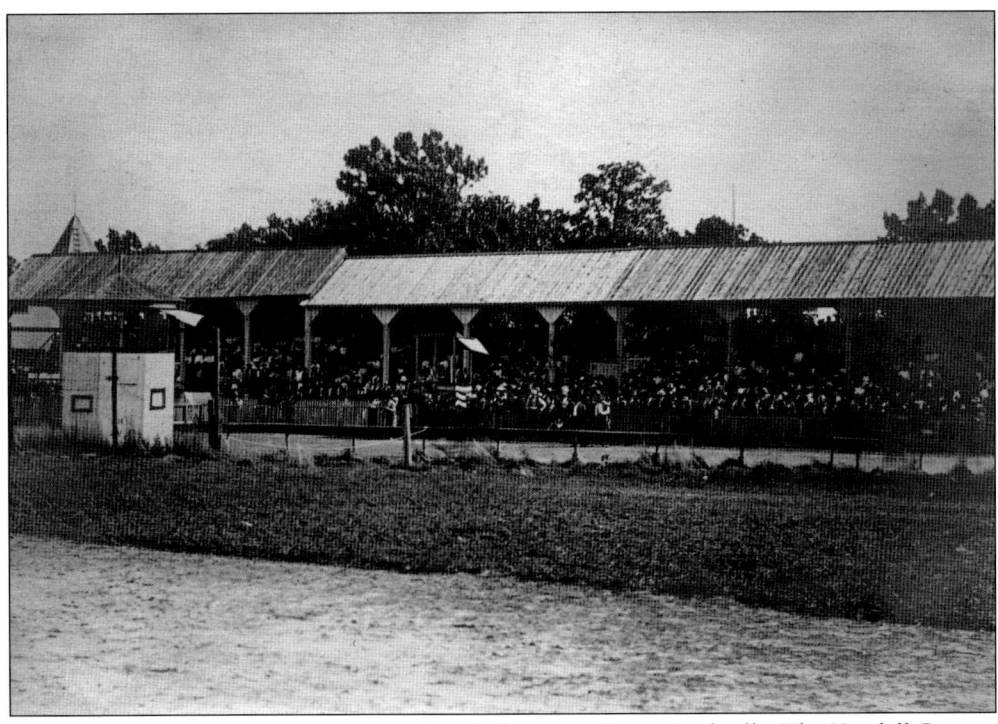

Spectators packed the grandstand at the Kendall County Fair in Yorkville. The Kendall County Agricultural Society held the annual county fair in Bristol from 1858 to 1906 on land that later became the Glen Palmer State Game Preserve. (Courtesy of the Little White School Museum.)

One

Two Towns Divided by a River

The Fox River, which meanders through Yorkville today, providing a picturesque backdrop for festivals at Bicentennial Riverfront Park and powering the state's only man-made whitewater course, once divided the community into two towns.

Earl Adams built the first log cabin in the area in 1833 on the prominent hill near what became Madison and Main Streets in what was originally known as Yorkville. A year later, he sold the cabin to brothers Lyman and Burr Bristol, who owned property north of the Fox River. The brothers picked their surname when they laid out a village north of the river, and then sold their claims south of the river to two cousins—Rulief Duryea and James Cornell, from New York. Drawing from the name of his home state, Duryea laid out the village of Yorkville south of the river in 1836.

Thus it remained for decades. Yorkville was named the county seat, although, for a time period, neighboring Oswego captured that duty, only to have Yorkville reclaim it in 1862. The Kendall County Agricultural Society held the annual county fair in Bristol from 1858 to 1906 on land that later became the Glen Palmer State Game Preserve. The downtown business district that still exists today developed along Bridge Street in Yorkville.

The first issue of the *Kendall County Record* was published on May 7, 1864, by John R. Marshall. "It is not only for the interest of the publisher that a paper should be sustained, but it is for the interest of the people also," Marshall writes in a prospectus announcing the new publication. "For the reason that every County should have an exponent of its own rights, a channel for local news; an advertising medium that will show the people what is transpiring among their merchants, manufacturers, professional men; an organ for local politics, as well as for the great questions of the day."

A train travels west across Yorkville in this view looking north across the Fox River into Bristol around 1900. The Fox River branch of the Chicago, Burlington & Quincy Railroad hosted the

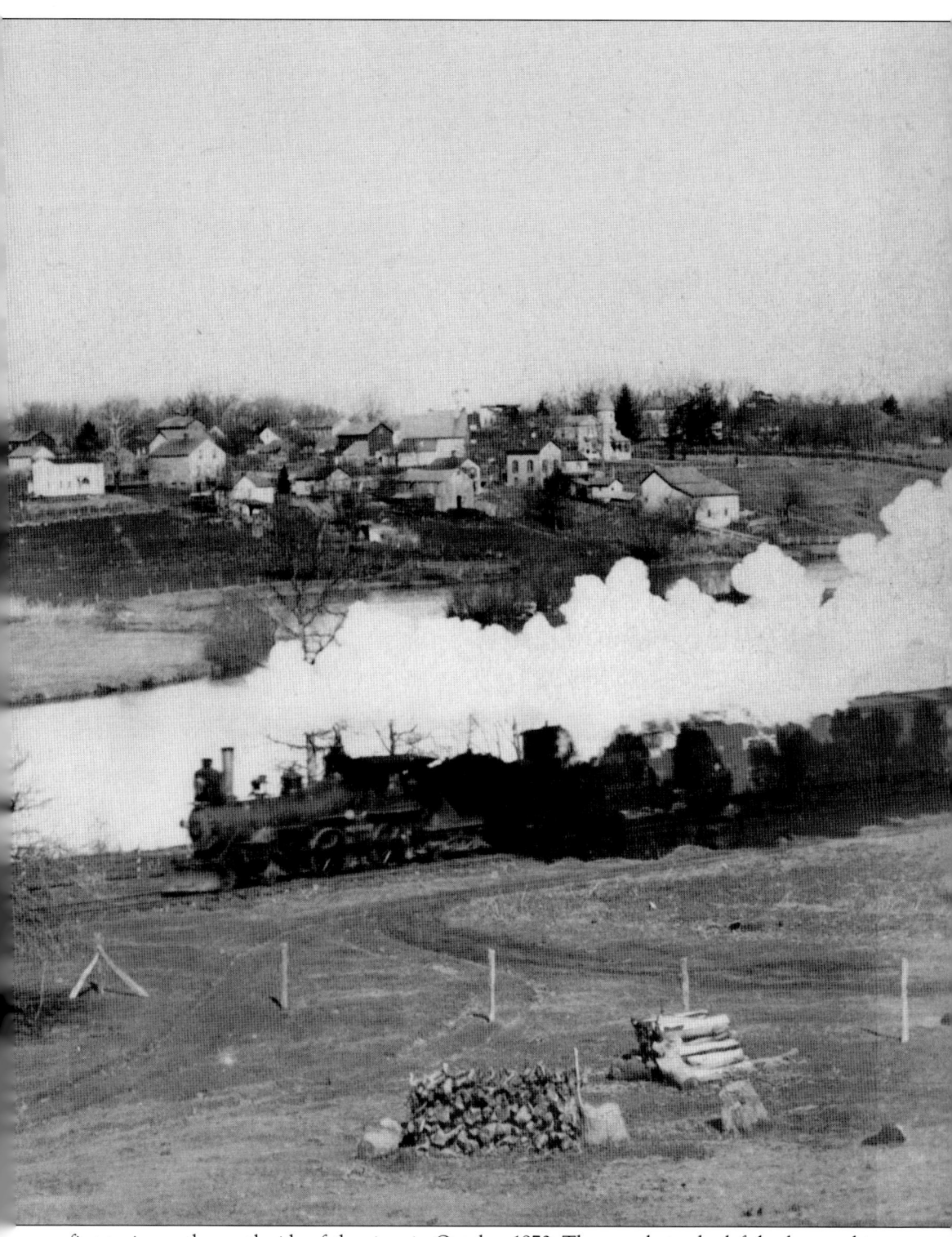

first train on the south side of the river in October 1870. The steeple in the left background is Parkview School, which was built in 1887. (Courtesy of Roger Weiss Jr.)

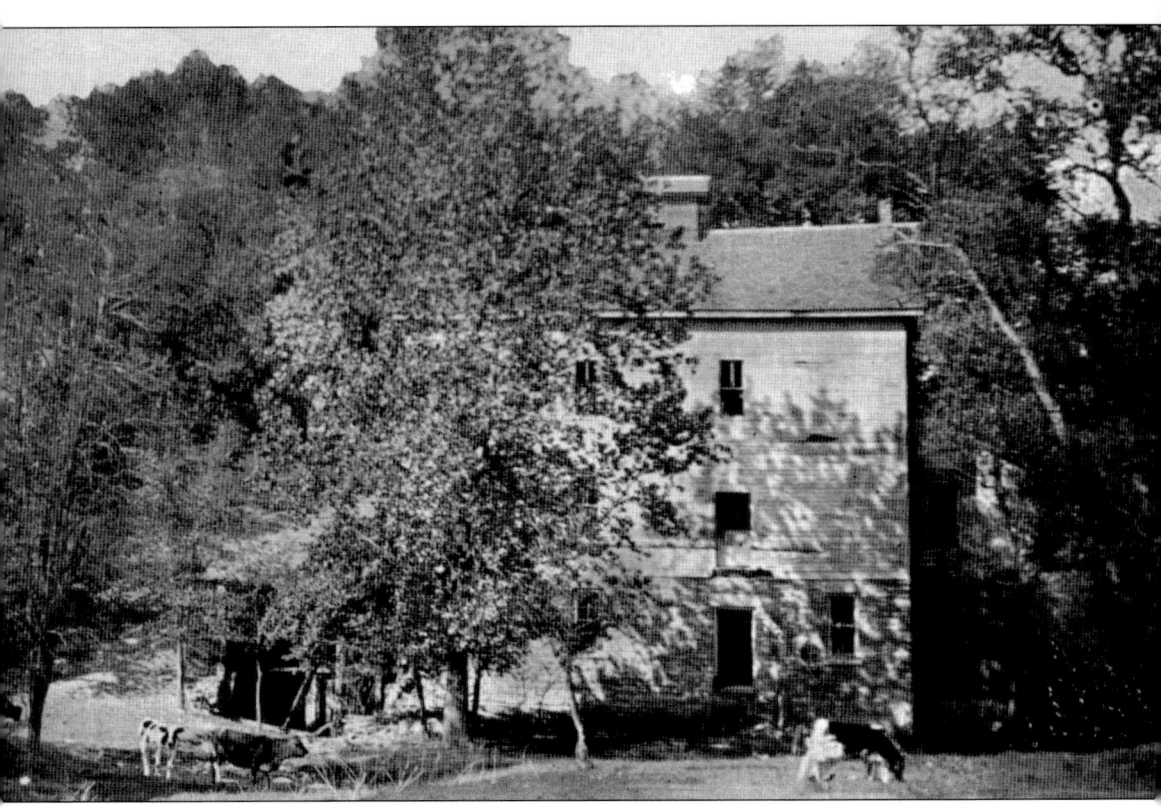

In 1833, John Schneider took a break from helping Capt. Joseph Naper build a sawmill in Naperville to select a site on the north side of the Fox River, at the mouth of Blackberry Creek, for a sawmill, according to Edmund Warne Hicks's *History of Kendall County*. About four years later, Lyman Bristol and Isaac Hallock bought the claim and mill for $7,000. (Courtesy of Roger Weiss Jr.)

Daniel Burroughs is one of two Revolutionary War soldiers buried in Kendall County. Born on May 28, 1755, Burroughs is buried in Griswold Cemetery, which sits south of River Road between Yorkville and Plano. In October 1777, when he was 22, Burroughs fought in the Battle of Saratoga, in which the Continental army and militia units led by Gen. Horatio Gates defeated about 7,000 British forces. In 2014, his gravesite was marked with a deteriorating headstone, a plaque from the Aliso Canyon Chapter of the Daughters of the American Revolution (DAR), and an inlaid marker from the Fox Valley Chapter of the National Society of the Sons of the American Revolution (NSSAR) and the Kendall County Genealogical Society. (Both, courtesy of the author.)

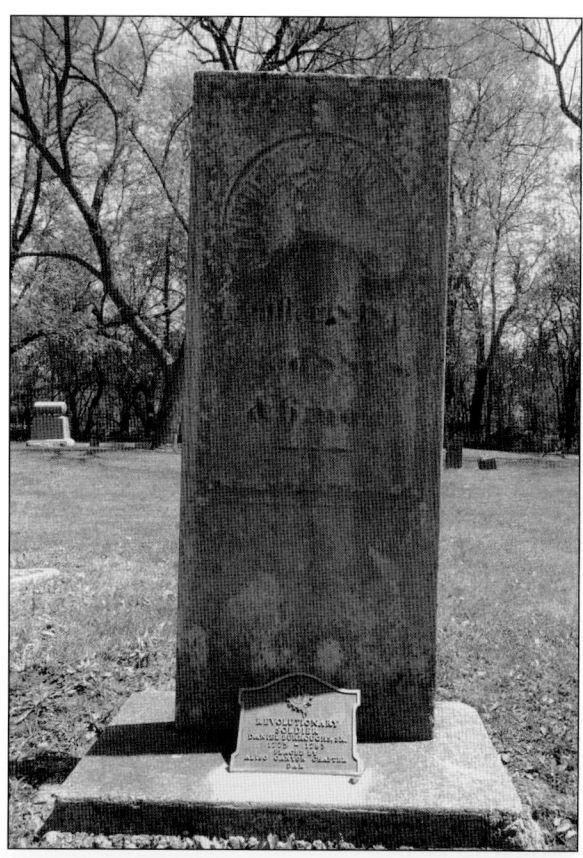

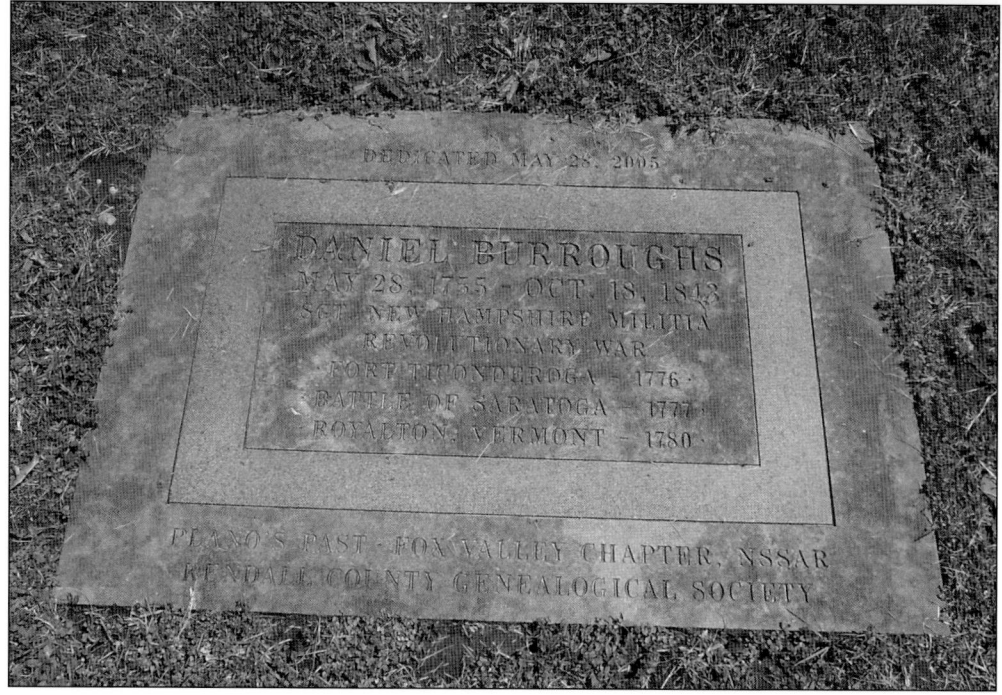

A horse seems to pose on the north bank of the Fox River in this undated photograph, which shows the power plant, creamery, and icehouse in its background. Yorkville incorporated as a village on July 8, 1873, with about 500 residents. Telegraph lines came to the village four years later. (Courtesy of Roger Weiss Jr.)

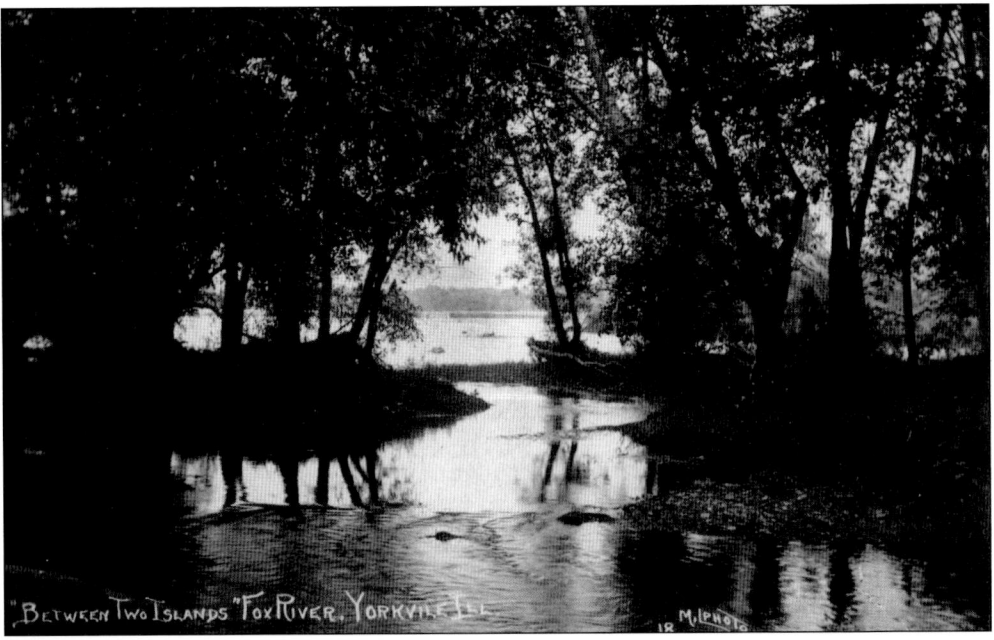

The Fox River is dotted with islands near Yorkville. A tributary of the Illinois River, the Fox River runs for 202 miles, from southeastern Wisconsin to Ottawa, Illinois. (Courtesy of Roger Weiss Jr.)

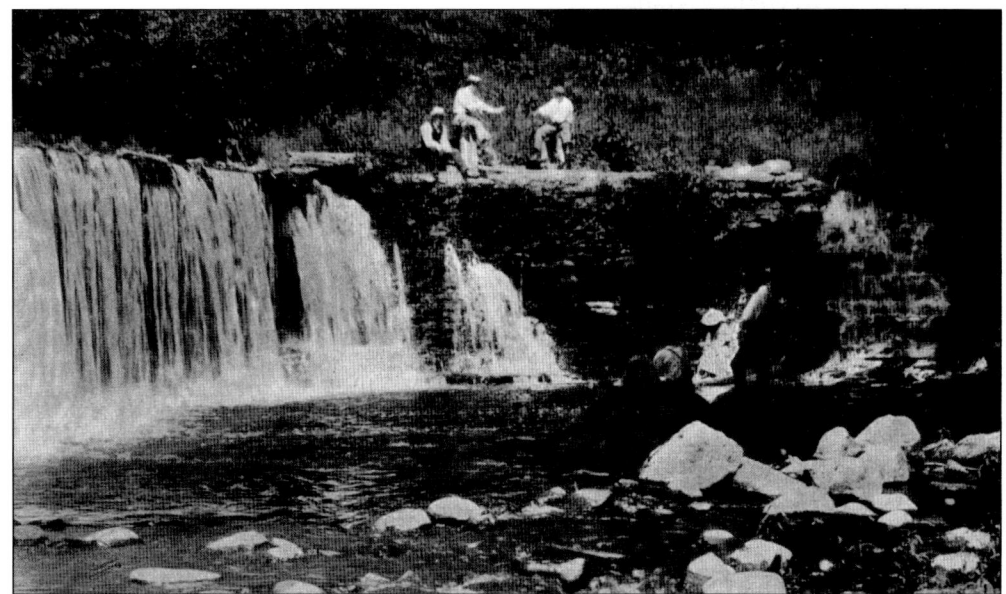

A dam across Blackberry Creek provided a nice spot for fishing. Blackberry Creek flows for about 32 miles, from Elburn to the Fox River west of Yorkville. At various times, it provided water for a state fish hatchery, a sewage treatment plant, and a city park. (Courtesy of Mark Johnson.)

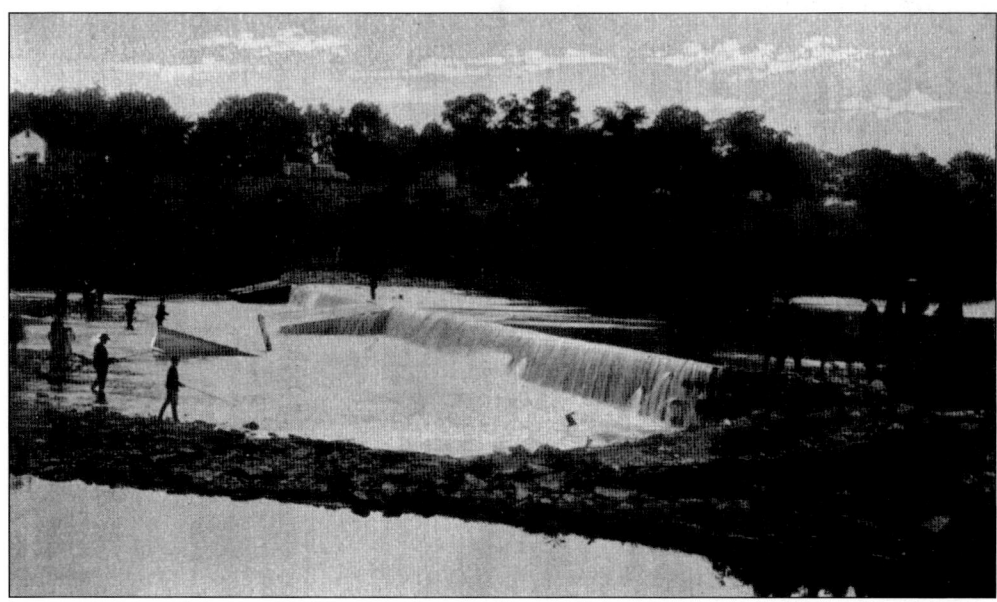

The water flowing west over the Fox River dam at Yorkville was shallow enough to allow fishermen to easily wade into it. In the early and mid-1900s, the area south of the dam was an unofficial dumping ground. (Courtesy of Mark Johnson.)

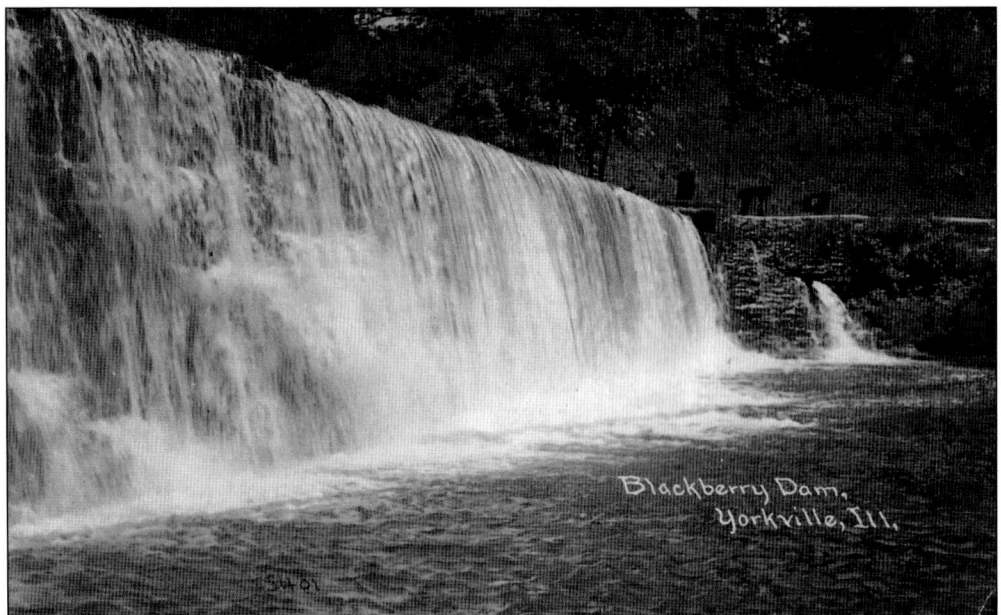

The Blackberry Creek dam, built in 1834 for a mill, was removed in early 2013. The creek itself provides plenty of memories: Susan Wagner writes that she remembers going fishing for catfish with her brother when she was 10 years old, "checking his traps for raccoons and tubing down the creek to the Route 34 bridge. Those were the days." (Courtesy of Roger Weiss Jr.)

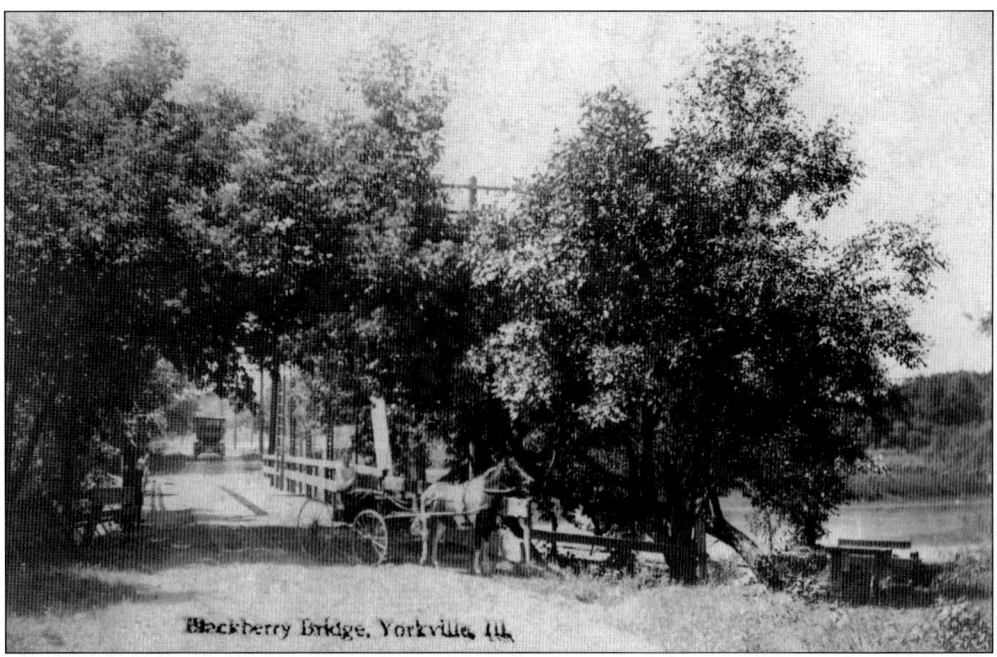

This picture postcard, postmarked 1909, shows the scene travelers would find along the River Road bridge over Blackberry Creek, which sits north of the Fox River. Mark Johnson remembers a steel span bridge with wooden boards that made a scary clunking sound as one crossed it, inspiring his father to tell scary stories before they crossed. (Courtesy of Roger Weiss Jr.)

Illinois officials bought the Advance Stock Food Company property in 1920 and created a fish hatchery in the area where Blackberry Creek meets the Fox River. The stock food company had purchased the old Blackberry mill and about 30 surrounding acres in April 1910 to grind feed. (Courtesy of Roger Weiss Jr.)

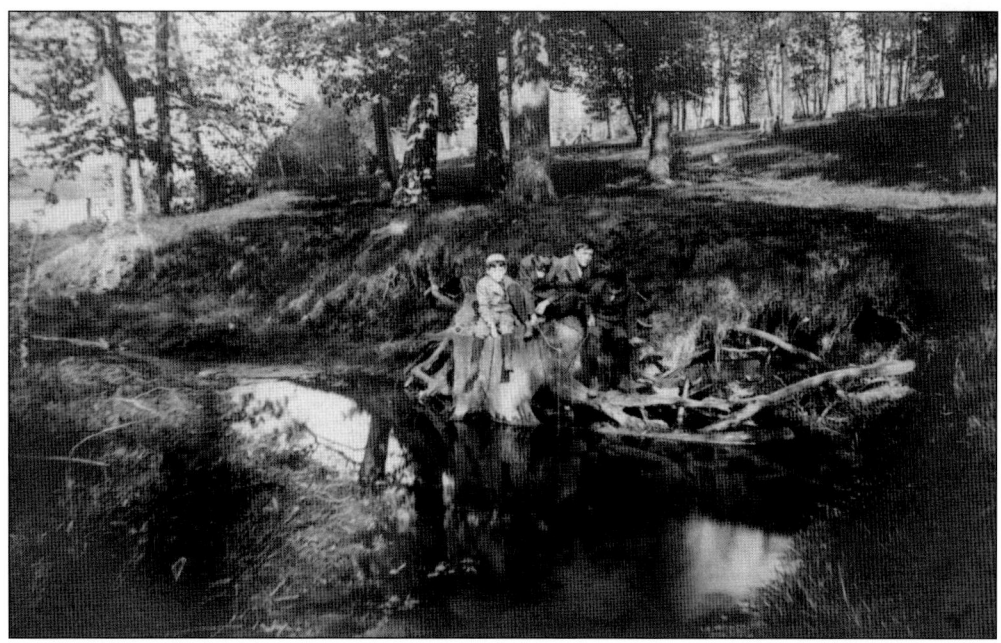
A group of boys poses on a tree stump in Blackberry Creek in this undated photograph. Blackberry Creek flows for about 32 miles, from Elburn to the Fox River west of Yorkville. (Courtesy of Thomas Milschewski.)

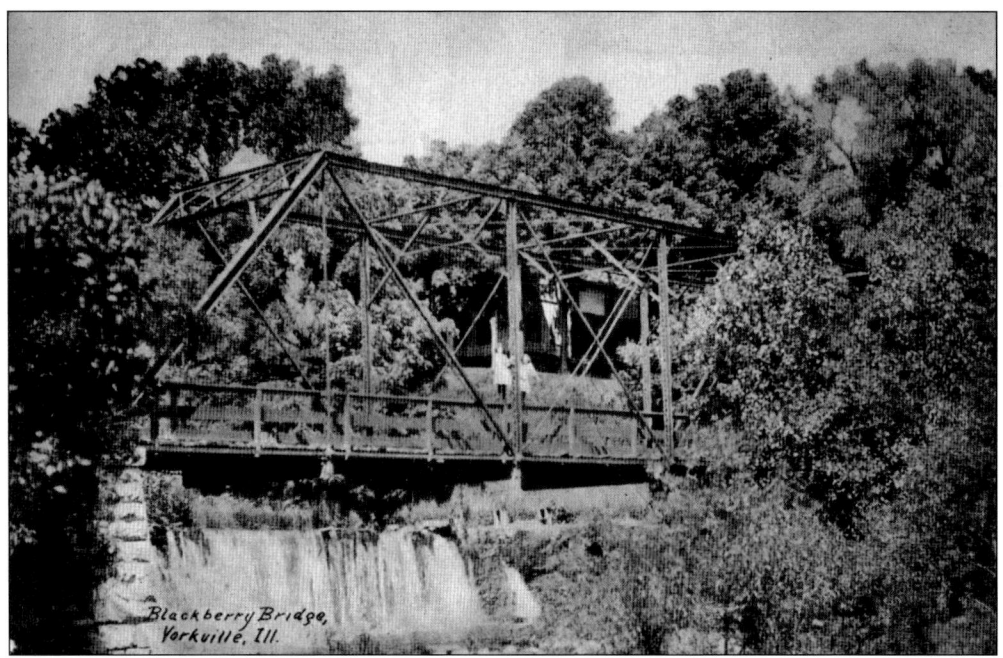

The River Road bridge over Blackberry Creek shared its western abutment with the dam, and a deep area south of the dam allowed a couple generations of brave children to dive off the dam into the cool water. Two unidentified children posed for this photograph around 1911. (Courtesy of Susan Kritzberg.)

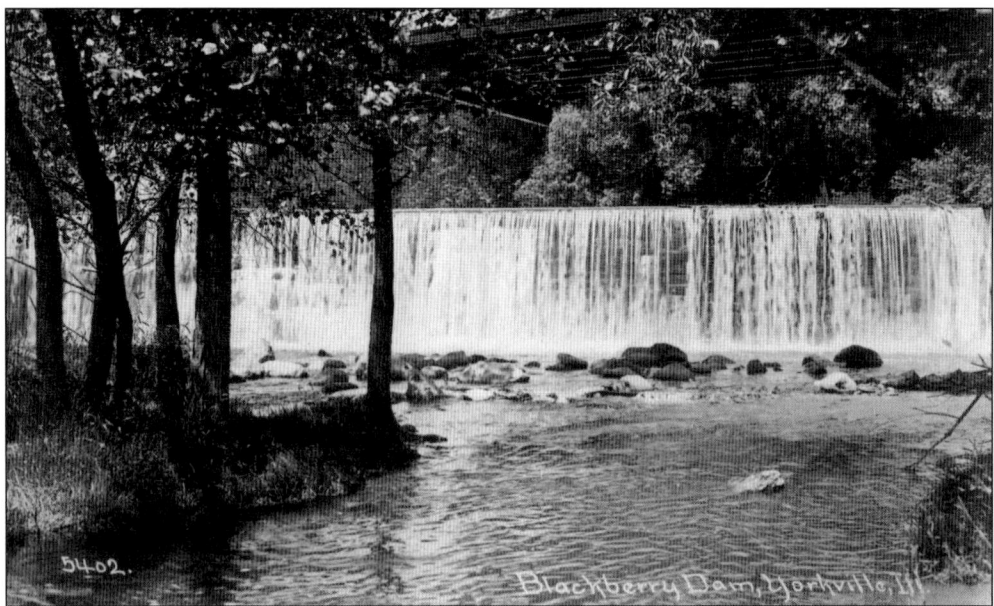

A photographer traveled up Blackberry Creek about 1914 to get this view of the dam from underneath the bridge. State officials closed the bridge in June 2011 after officials noticed that a crack in the western abutment, which it shared with the dam, was worsening more quickly than expected. (Courtesy of Roger Weiss Jr.)

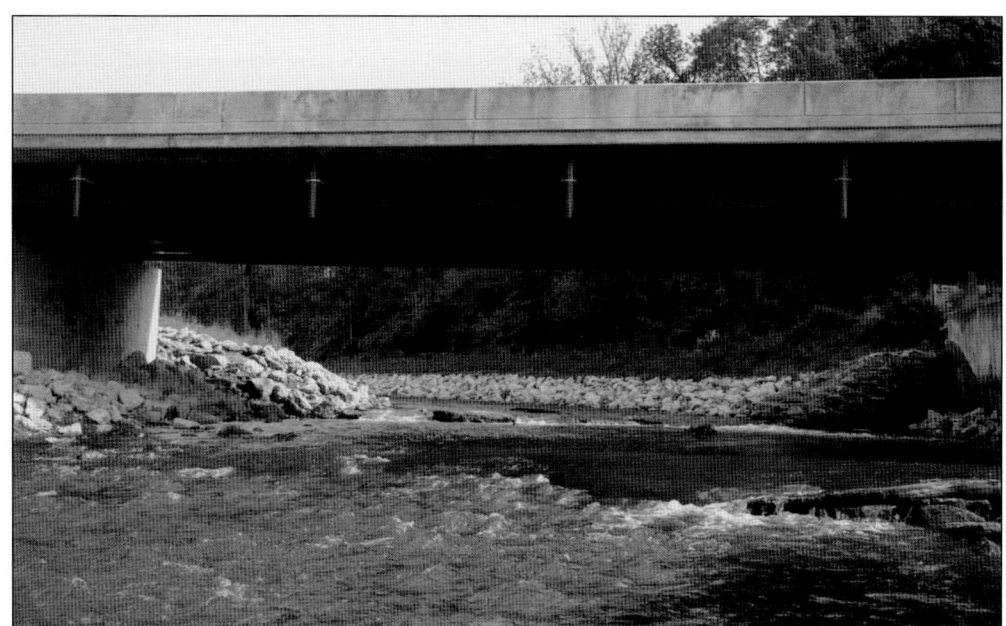

State officials removed the Blackberry Creek dam and replaced the River Road bridge, opening the road to traffic in July 2013. That roadway saw about 4,500 vehicles a day in 2008, so residents were happy to be able to use the artery to Plano again. State officials expected that fish and other wildlife would be happy that the dam, which was not replaced, no longer restricted their upstream movement. (Above, courtesy of Michalene Bell; below, courtesy of the author.)

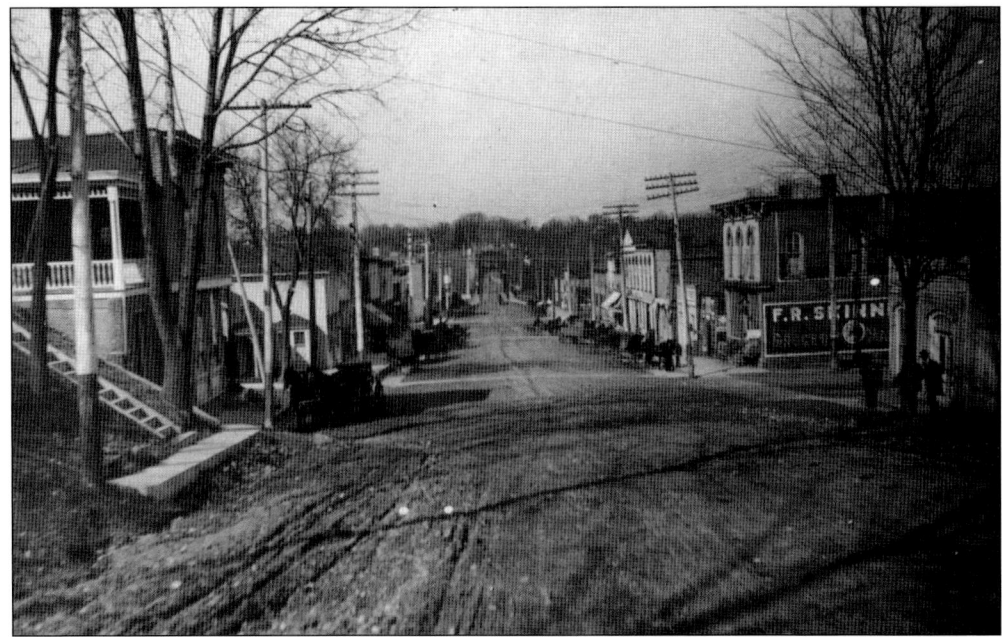

This photograph provides a northerly view of Bridge Street from just south of Van Emmon Street around 1900, with the street narrowing for the bridge over the Fox River. The bridge was widened to four lanes in 1984. (Courtesy of Barry J. Lauwers.)

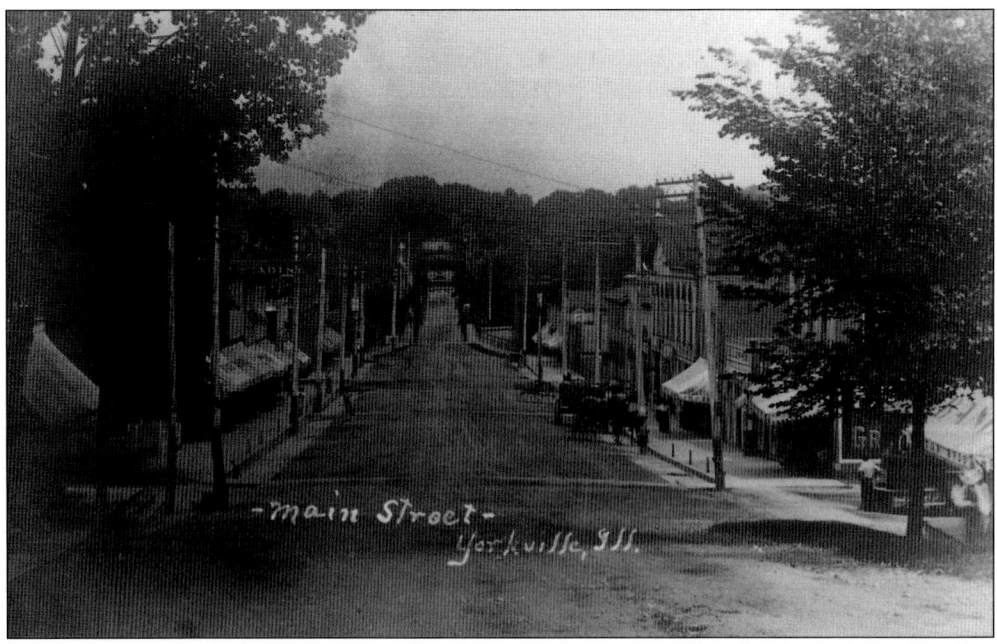

Yorkville's main bridge was actually two structures that met on an island in the middle of the Fox River. The first cement sidewalk was laid along Bridge Street in 1897 in part of the business district that had grown in the three blocks south of the river, but the rest of the sidewalks, including those flanking the bridge, remained wooden plank. (Courtesy of Roger Weiss Jr.)

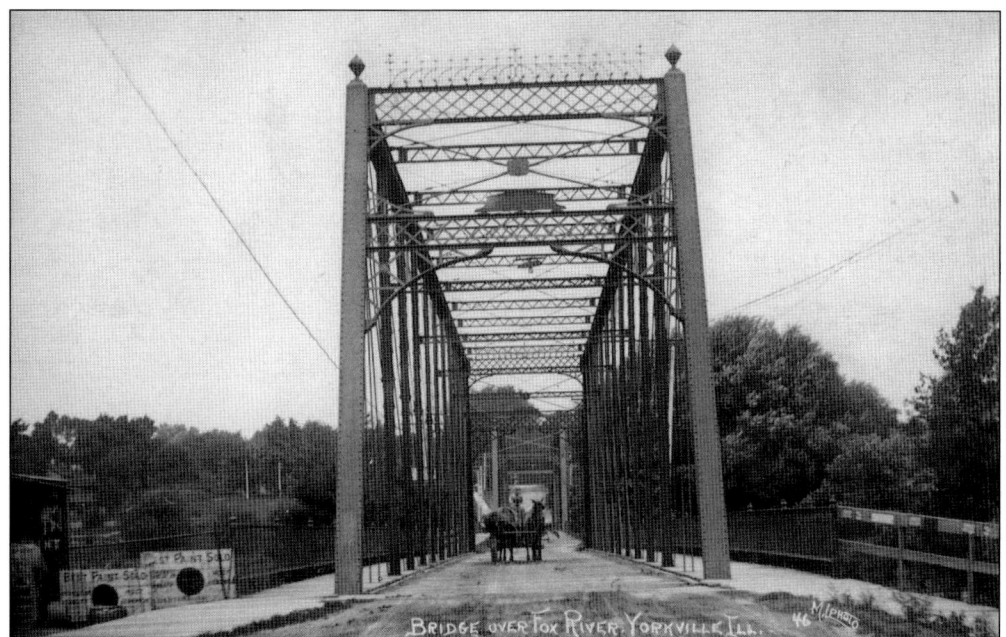

The Illinois Department of Transportation built Route 47 from Route 34 to the Fox River in 1923, and then resumed building the state highway south of the river in 1928. Downtown business managers were so concerned about the loss of business and property that $6,000 in bonds were sold to reimburse them. Yorkville marked the road opening with free music from a band, movie, and street dance on August 17, 1929. The mayor formally invited everyone via a notice on the front page of the *Kendall County Record*. (Courtesy of Roger Weiss Jr.)

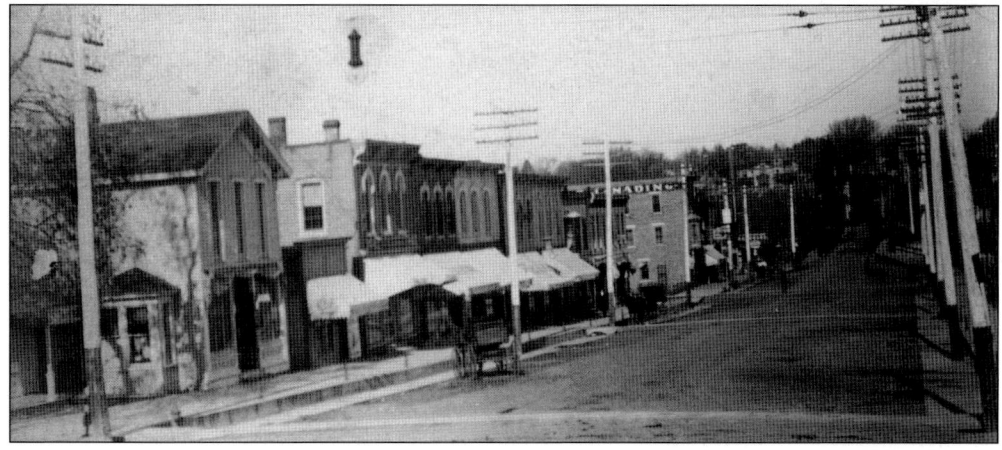

A coal-operated plant near the railroad tracks east of Bridge Street brought electricity to Yorkville on November 5, 1898, although the plant sometimes shut down when the railroad shipment was late. This photograph shows that electric wires had been strung along downtown Yorkville at a time when many still relied on horsepower for transportation. (Courtesy of Thomas Milschewski.)

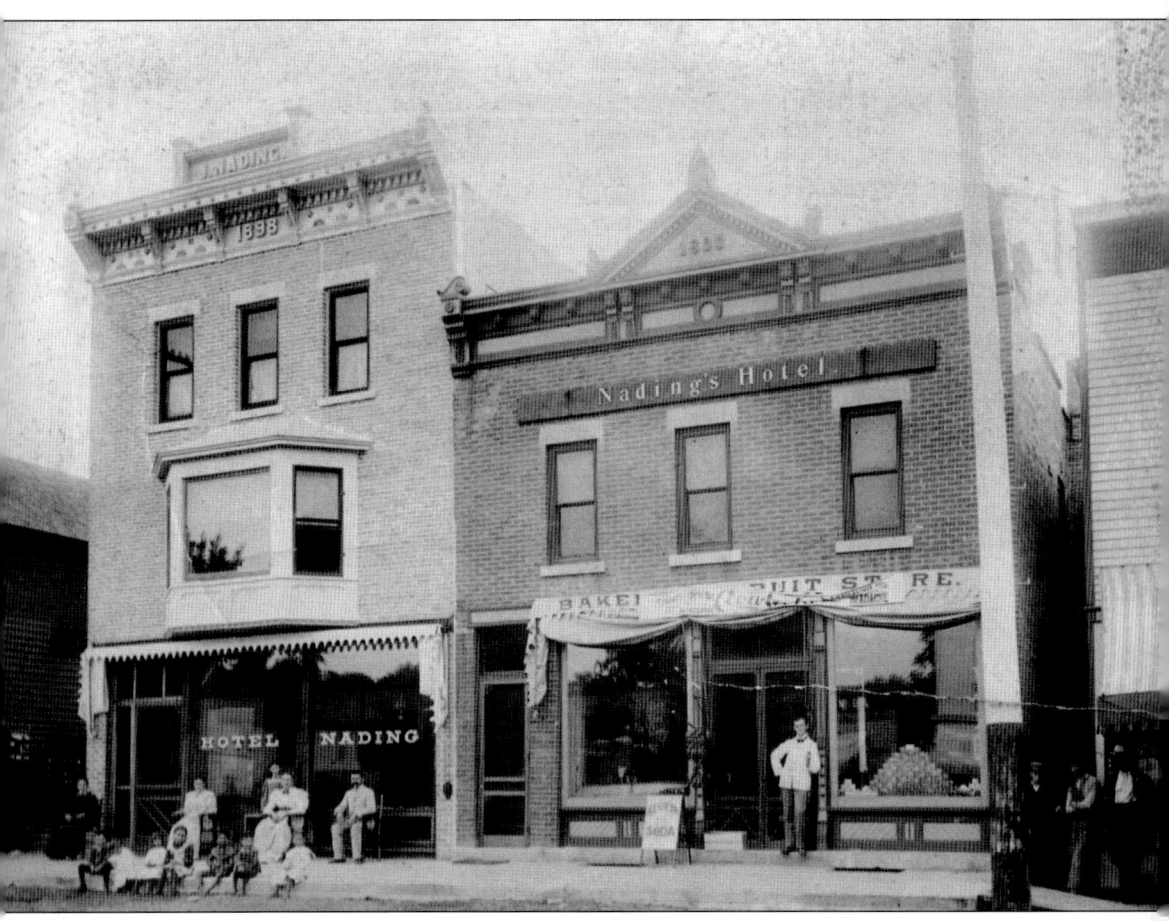

Justus Nading, a German immigrant, opened a bakery and store in 1884, later adding four sleeping rooms in the back. About a decade later, in the same lot, he built a three-story hotel with 30 rooms, hot and cold running water, and an indoor toilet in the basement. Nading added a telephone exchange in 1897. He eventually gave up control of the hotel but still managed the exchange until he retired in 1932. (Courtesy of Roger Weiss Jr.)

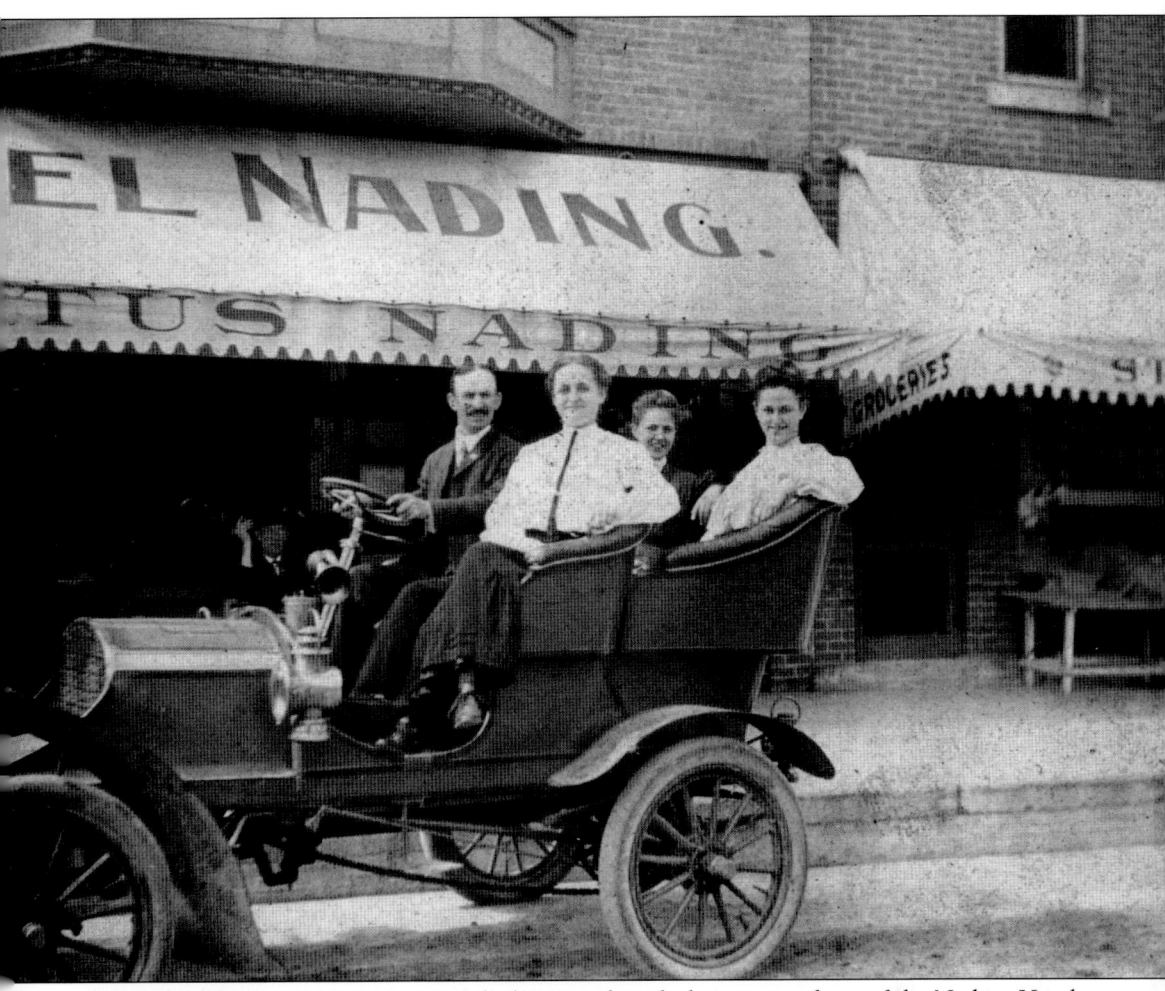

J.E. Bates of Plano poses in his car with three unidentified women in front of the Nading Hotel in this undated photograph. During the height of Prohibition, which ran from 1920 to 1933, the Nading Hotel hosted some illicit activity. Manager Frank Mikula was sentenced to 90 days in jail for making beer in the hotel basement, according to a September 22, 1926, article in the *Kendall County Record*. Suspicions arose after Mikula and Durston Ohse got in a fistfight with Carl Riemenschneider that resulted in Ohse and Mikula being hauled to jail, according to the article. "Certain admissions aroused the suspicion of the officer and a search warrant was issued with the result that the incriminating evidence was found," the article reports. Mikula's wife ran the hotel in his absence. "The people of the village sympathize with Mrs. Mikula in her misfortune," the article states. "The hotel is one of which every small town could be proud and Mrs. Mikula should not be the loser by this circumstance over which she has no control." (Courtesy of Roger Weiss Jr.)

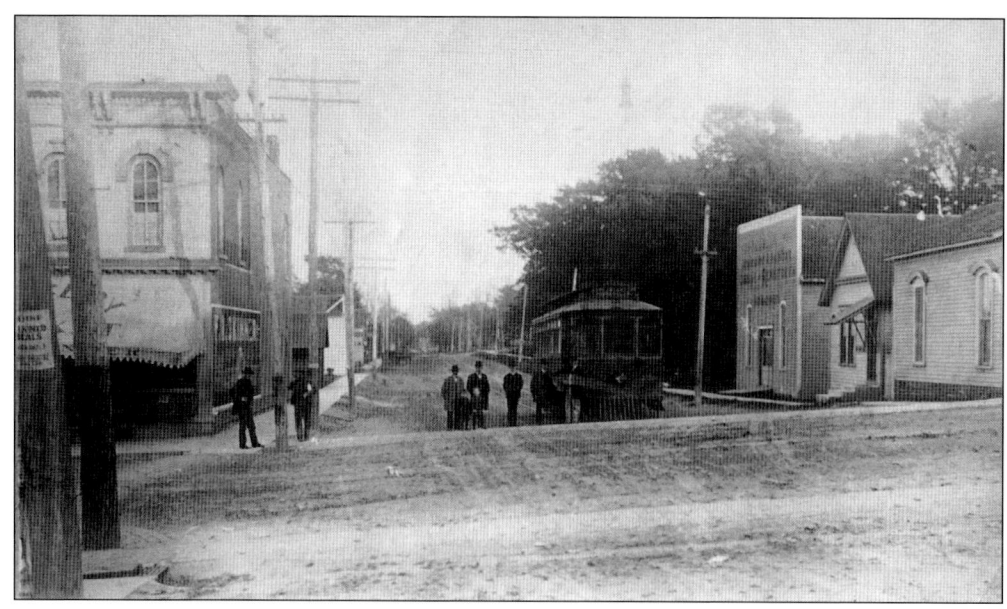

The Chicago, Aurora & Elgin Interurban Railway came to Yorkville in 1903, with the ride from Yorkville to Aurora taking about an hour. This photograph above, taken about 1908, shows the train facing west on Van Emmon Street at Bridge Street. In January 1913, the Fox & Illinois Union Electric Railway started running from Yorkville to Morris, connecting to both the interurban and the Chicago, Burlington & Quincy Railroad line. The interurban railway stopped in 1925, and the Fox & Illinois Union Electric Railway stopped in 1938. (Above, courtesy of Roger Weiss Jr.; below, courtesy of the Little White School Museum.)

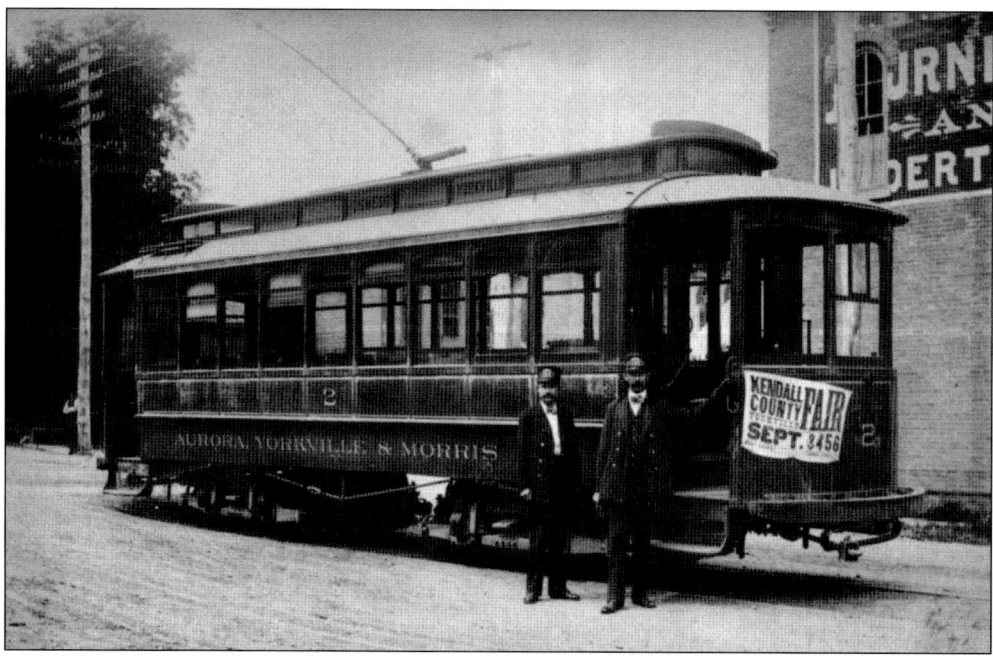

26

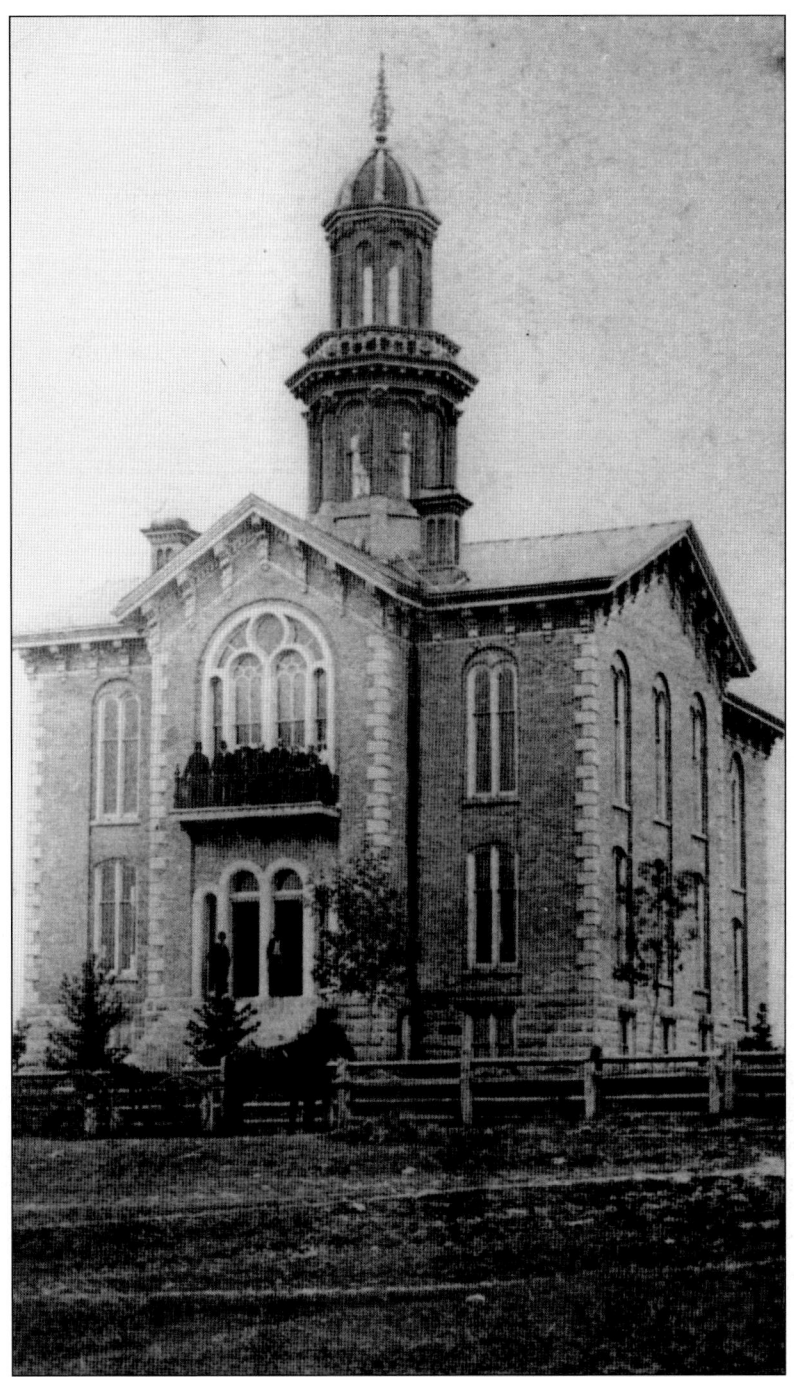

Kendall County's limestone and brick courthouse was finished in 1864, and it burned in a fire that started about 4:00 a.m. on March 25, 1887. Yorkville did not have a fire department then, so its citizens were forced to rely on railroad water cars that did not arrive from Aurora in time to save most of the structure. The sheriff, his family, and two jail inmates were rescued, though. The fire's cause was never determined, but it was believed to have started in a coal stove in the sheriff's residence. (Courtesy of Susan Kritzberg.)

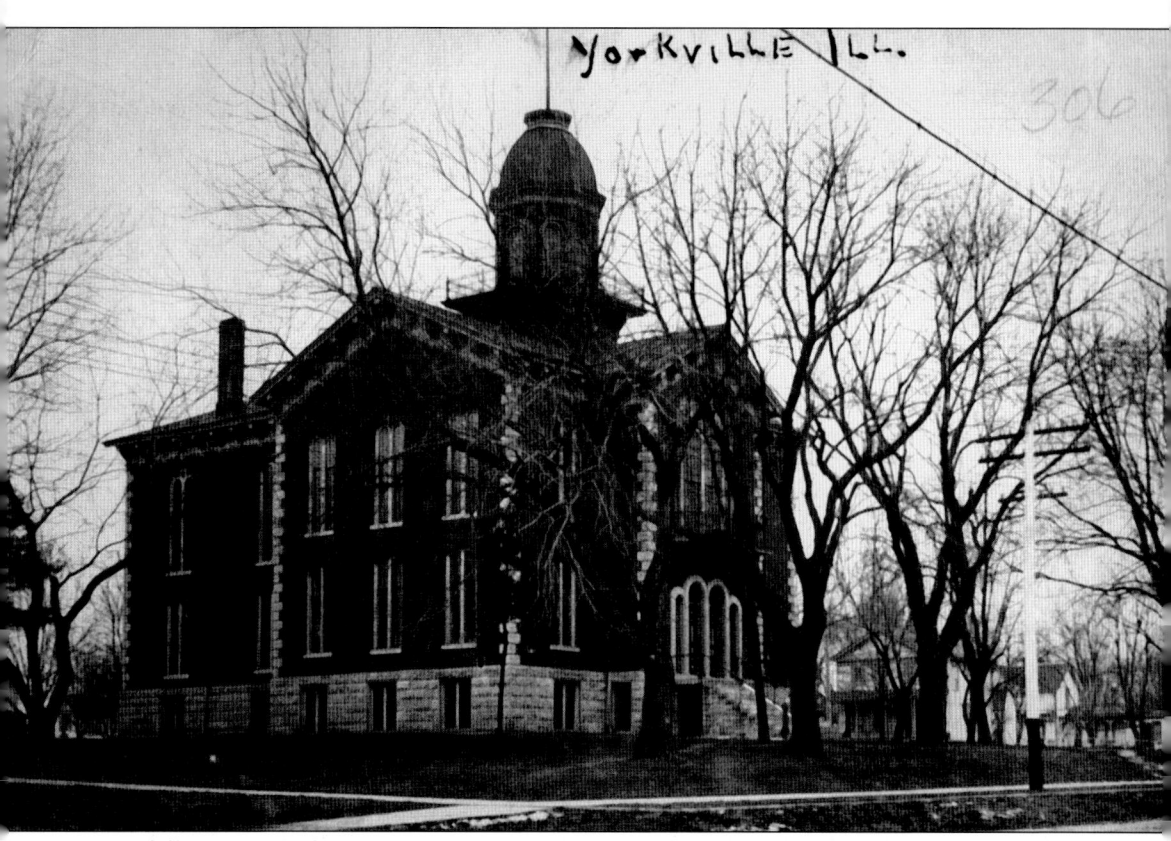

Kendall County residents rebuilt the courthouse, replacing the two-story cupola with a one-story dome, which was removed in 1920 because of water leakage. Two wings were added in 1958, and the building was used as a courthouse for 40 more years. About two years after the county offices moved to a new campus west of Yorkville, a restoration project kicked off in 2000. (Courtesy of Roger Weiss Jr.)

Two

Growing Commerce and Community

The beginnings of industry spanned both sides of the Fox River. John Schneider built a sawmill on the mouth of Blackberry Creek in Bristol in the 1830s, while the Squire Dingee Pickle Factory operated for a few years south of the river in the early 1900s and the Rehbehn brothers operated a button factory on the south side of the river from 1911 to 1914. Most teenagers also worked, perhaps on the family farm, detasseling corn, cutting asparagus on a 15-acre farm on McHugh Road, or some combination thereof. Alice and Homer Dickson started a farm implements business on Bridge Street near the river in the 1930s, later adding a plumbing and heating business and partnering with Ira and Lillian Perkins in the Yorkville Appliance & Furniture Company.

The relatively new Kendall County Courthouse, at Main and Madison Streets, burned until only its exterior walls remained standing in 1887, but it was rebuilt, and a new brick jail was built across the street in 1893.

"It was real busy on a Saturday night downtown," John Schneider said during a 2011 oral history interview for the Yorkville Public Library. "There wasn't much going on at night otherwise. All the farmers came to town with their eggs and to buy groceries for the week and whatever."

Although the community had its moments of excitement—including Jawaharlal Nehru, prime minister of India, visiting the Peterson family farm, east of town, in October 1949—the town remained a place where residents never locked their doors. However, they may have learned plenty about their neighbors on the shared telephone line.

"I remember our telephone number was 104R1," said Don Ament, whose family farmed south of Yorkville. "That was party line, where you could pick up and hear the clicks down the line. That was the greatest newspaper you ever had."

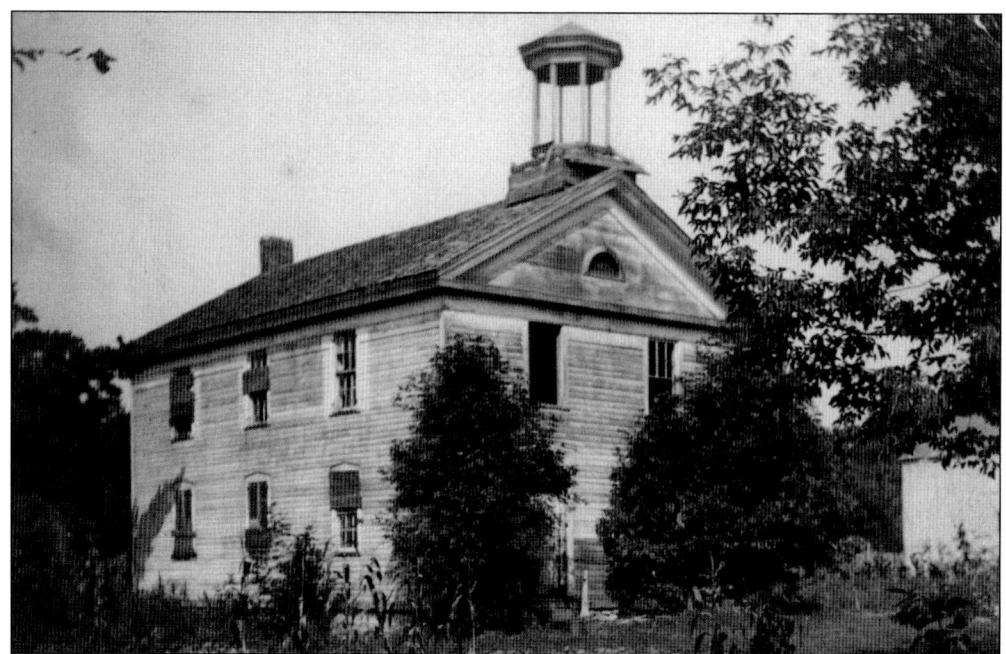

This two-story building at 211 East Spring Street was used as a school in Bristol from the early 1850s until 1887. It was later used as a house. On the Yorkville side of the river, a brick house on the northwest corner of State and Fox Roads served as a school starting in 1837. Yorkville and Bristol created a unified school district in 1883. (Courtesy of Thomas Milschewski.)

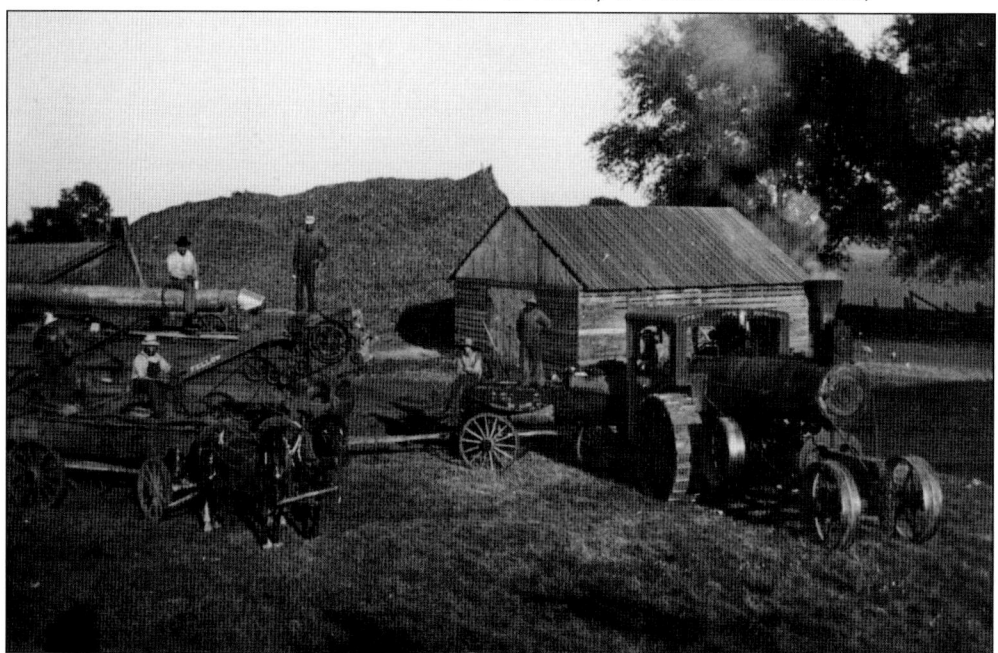

Farmers pause from their work to pose for this undated photograph. Agriculture was the predominant industry in Yorkville for decades before the Kendall County Farm Bureau started in June 1920, with an office in the courthouse, an adviser with a touring car, and 1,003 members. (Courtesy of Jeff Scull.)

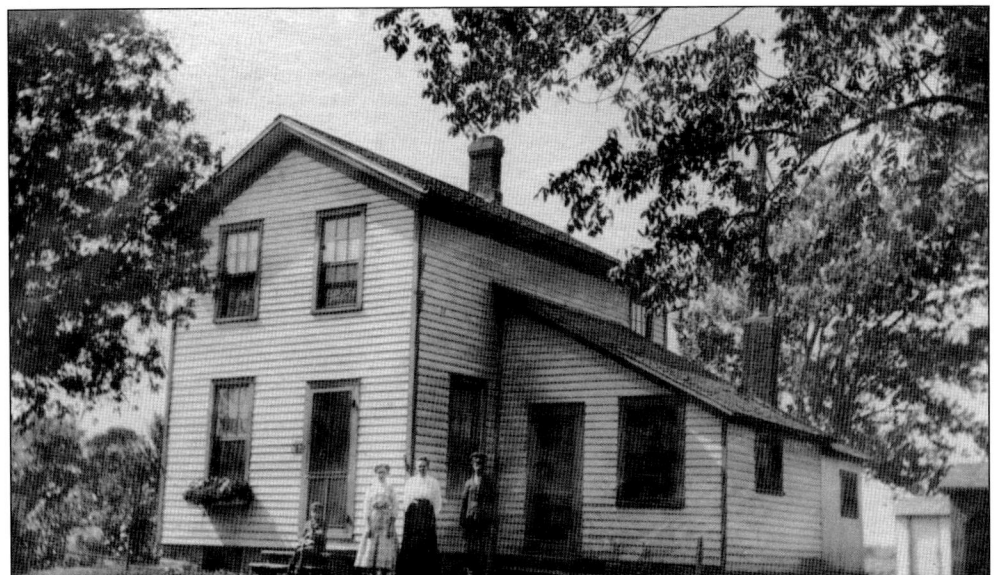
The Herren family poses outside their Kendall Township home in 1909. Pictured, from left to right, are Earl Leslie Herren, Ethel Herren, Lilly Van Dreesen Herren, and Charles Herren. Charles was a farmer who was killed in September 1934 when he fell from a load of hay at age 71. At the time of the 1920 census, Ethel was working as a schoolteacher. (Courtesy of the Little White School Museum.)

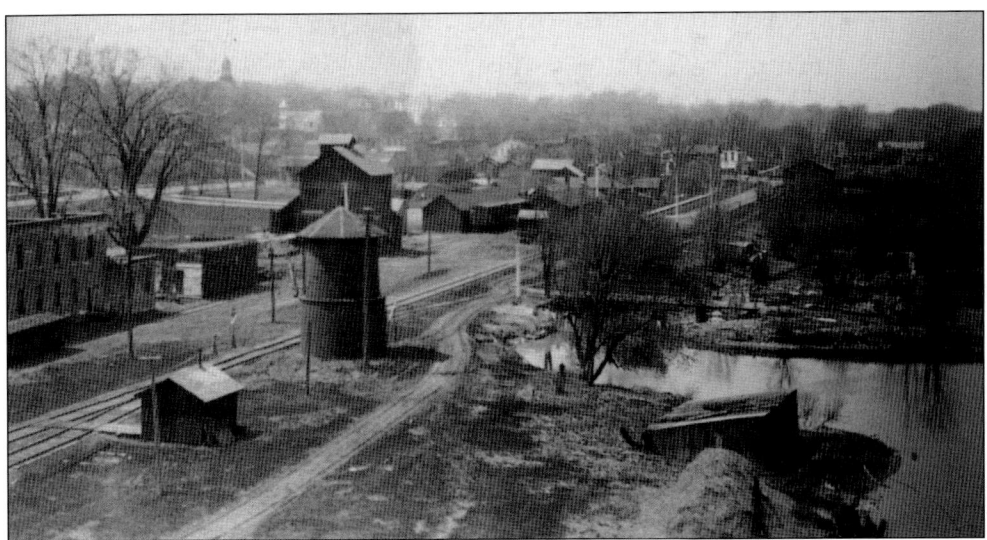
The Jeter & Boston elevator, the button factory, and part of the power plant can be seen in this undated photograph showing the south bank of the Fox River east of Bridge Street. The Rehbehn Brothers button factory moved into the former City Hotel building, where 15 to 20 employees punched buttons out of clam shells from the Fox River. (Courtesy of Thomas Milschewski.)

The short, descriptive style emphasizing the proprietors' images in this undated card seemed common for advertisements in early Yorkville. In *Kendall County Record* advertisements in 1898, Justus Nading's photograph, with him sporting slicked-back hair and a thick mustache, was seen next to promises that the hotel was "first-class in every respect; heated by steam; every accommodation for travelers." (Courtesy of Susan Kritzberg.)

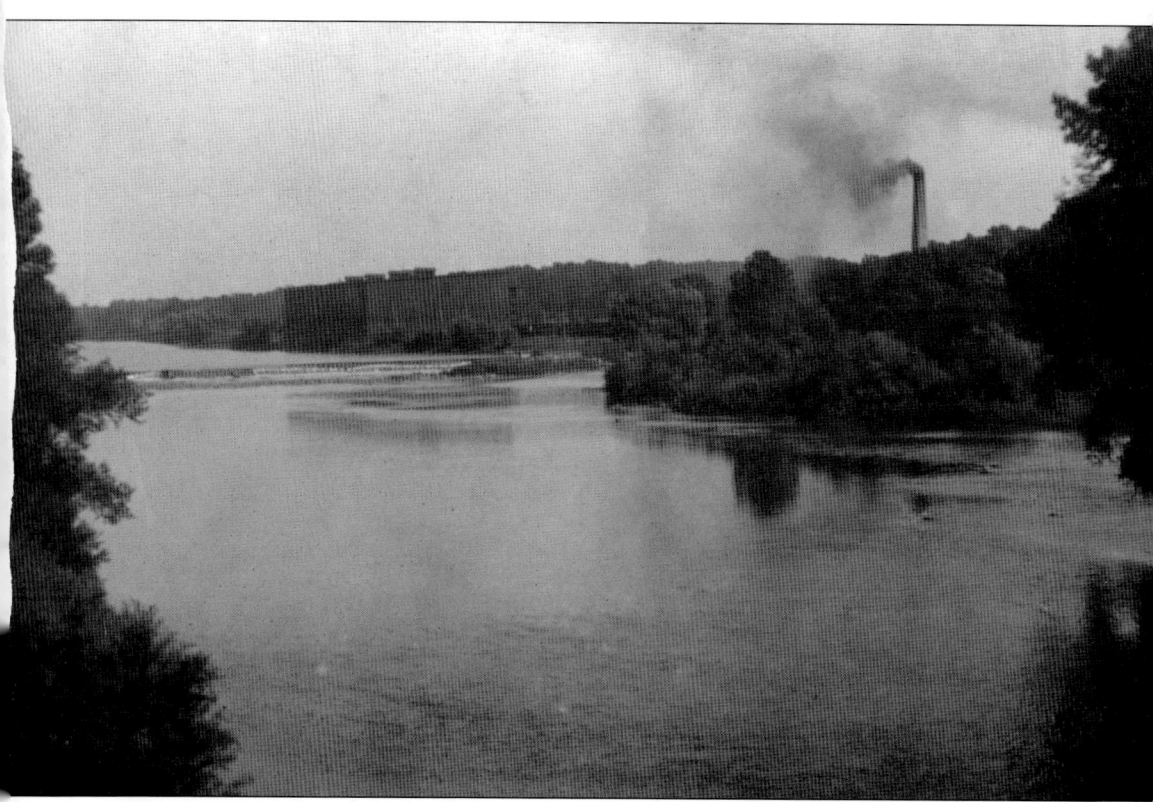

Almost obscured by the trees, an icehouse sits east of the dam on the Fox River's south bank. The vast building—four stories high and two blocks wide—rocked in the wind, so logs were propped against its sides to steady it. The structure burned in 1902. (Courtesy of Barry J. Lauwers.)

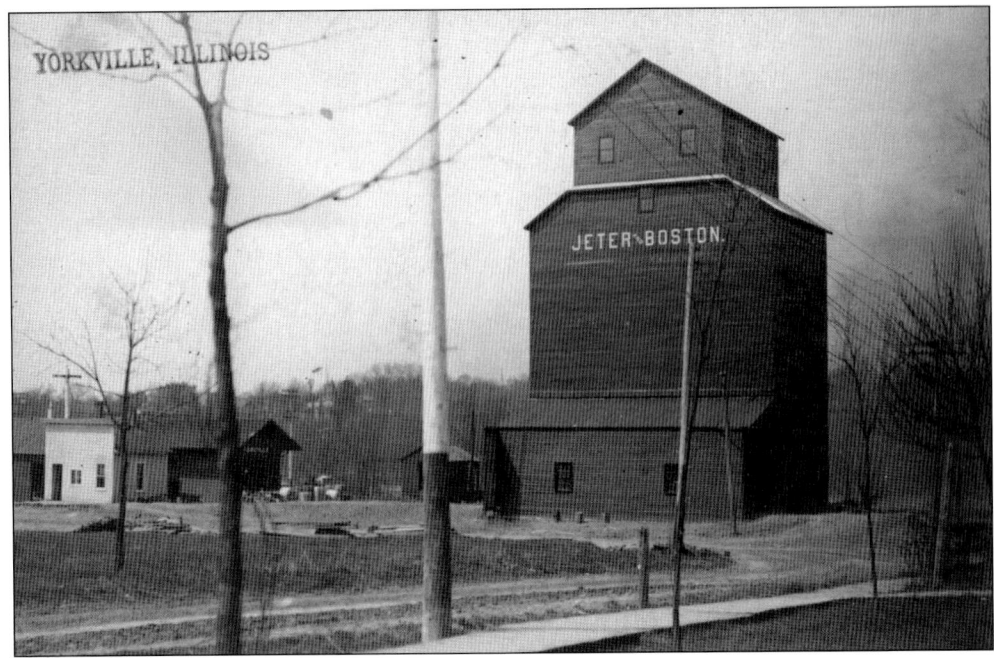

The Jeter & Boston yard and elevator sat on the south side of the Fox River. A March 16, 1898, advertisement in the *Kendall County Record* indicates the business bought grain and grass seed and sold lumber, laths, shingles, lime, cement, and other building materials. (Courtesy of Thomas Milschewski.)

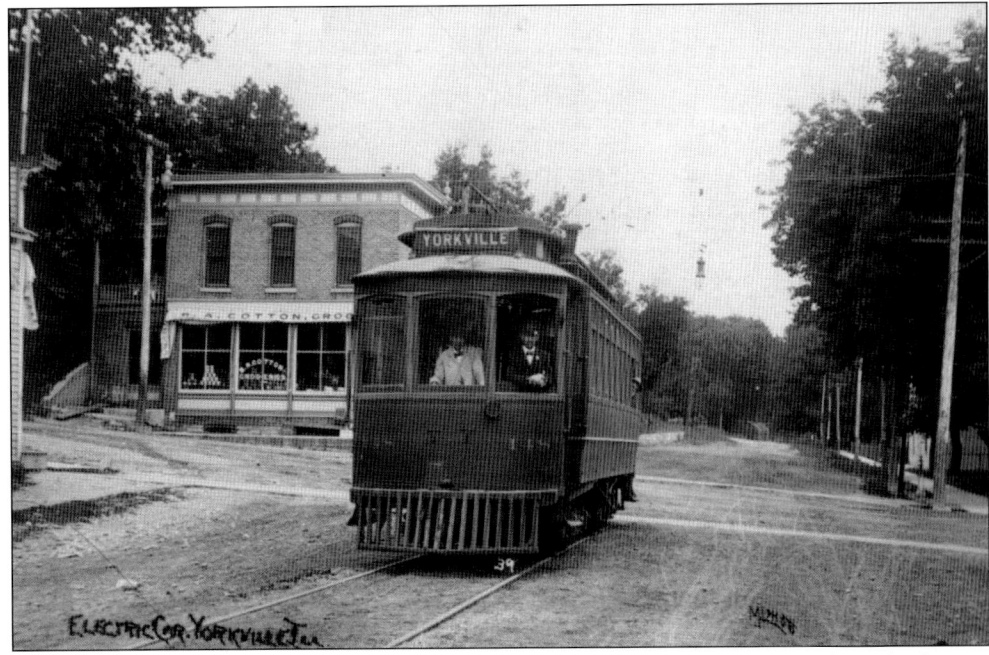

The interurban train runs east on Van Emmon Street in this image, showing the B.A. Cotton Grocery building in the background. The masonry building was demolished in 2012 so the Illinois Department of Transportation could widen Route 47 through town. (Courtesy of Thomas Milschewski.)

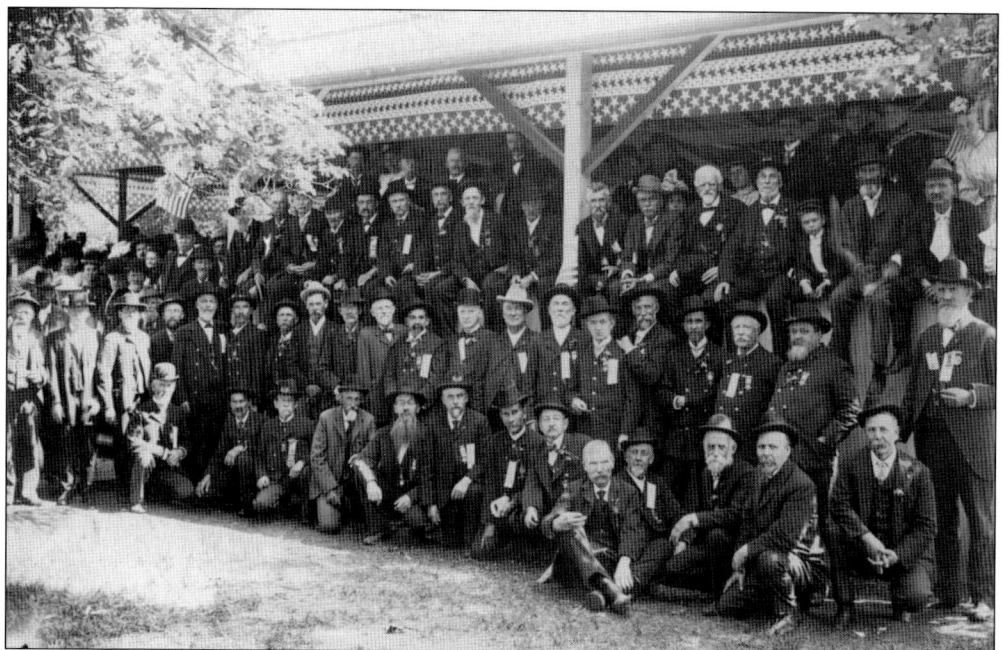

The Yorkville Grand Army of the Republic (GAR) post is gathered at the Kendall County fairgrounds in Bristol for a group photograph. A fraternal organization for Union Civil War veterans, the GAR was founded in Decatur, Illinois, in 1866 and dissolved in 1956 when its last member died. (Courtesy of the Little White School Museum.)

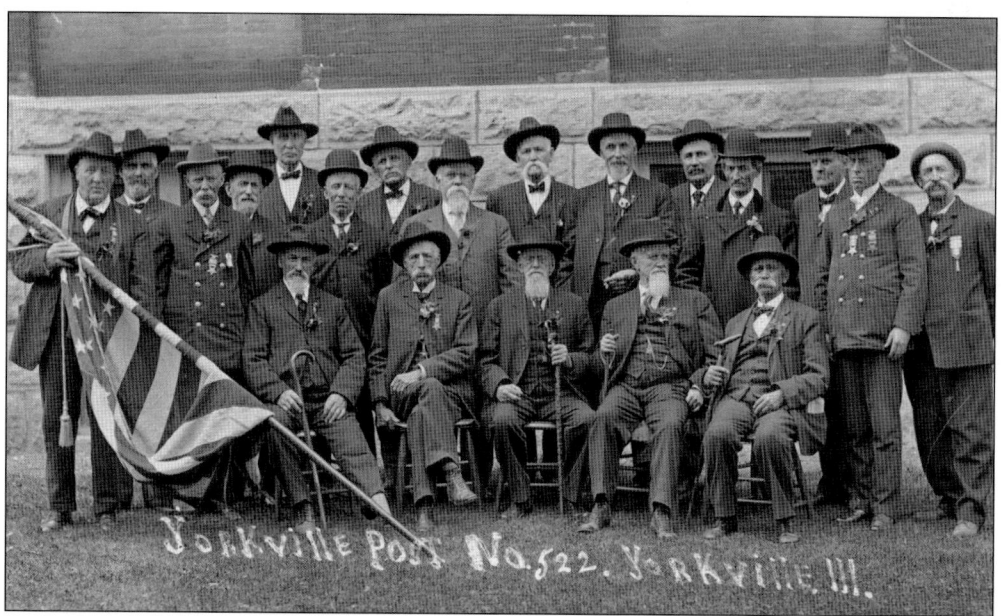

Yorkville GAR Post No. 522, which typically met at the Kendall County Courthouse, at Main and Madison Streets, poses for this photograph before 1914. Orville Beebe is standing second from the left, while Myron Skinner is sitting on the far left in the first row. Skinner wore a peg leg after being shot in the war. (Courtesy of the Little White School Museum.)

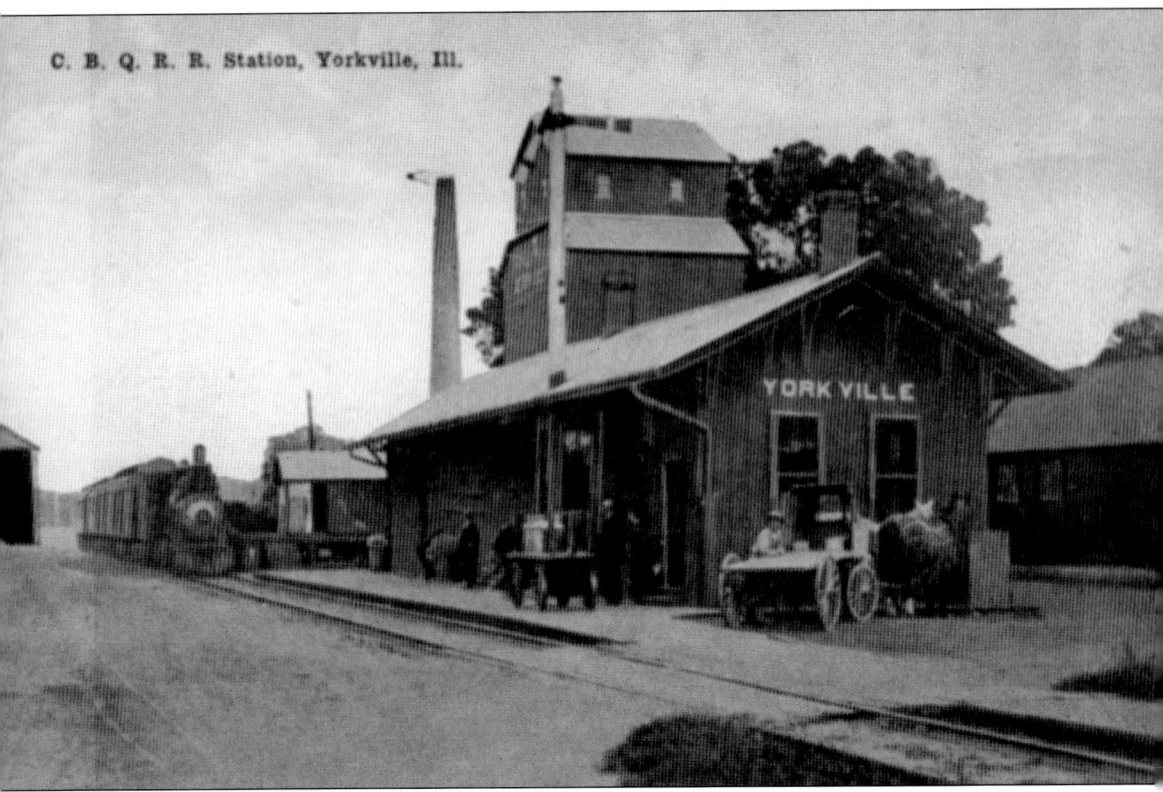

Immediately east of the Jeter & Boston elevator and yard was the Chicago, Burlington & Quincy station. The Fox River branch of the Chicago, Burlington & Quincy hosted the first train on the south side of the river in October 1870. (Courtesy of Thomas Milschewski.)

Jens Knutsen Todnem, who also once operated an ice company, ran Todnem's Market, on the northeast corner of Bridge Street and Hydraulic Avenue. The market sat between Fred Ohse's grocery store and the onetime location of the Yorkville library. (Both, courtesy of Mark Johnson.)

37

Irving Weiss (right) and an unidentified man pose for this photograph at the Kendall County Fair in 1906. From 1858 to 1906, the Kendall County Agricultural Society hosted the fair, which included horse races, on property that later became part of the Glen Palmer State Game Preserve. (Courtesy of Roger Weiss Jr.)

Clint "Dick" Houck works at the anvil in his blacksmith shop, as Irving Weiss sits in a chair behind him. The blacksmith shop sat north of Hydraulic Avenue and east of Bridge Street. (Courtesy of Roger Weiss Jr.)

This view of Bridge Street looking south from the Fox River shows the road curving up to the courthouse. The Illinois Department of Transportation built Route 47 from Route 34 to the Fox River in 1923, and resumed building the state highway south of the river in 1928. (Courtesy of Roger Weiss Jr.)

The Eagle Threshing Company crew worked with a new Case steam engine in 1910. The men took the time to pose for this photograph with it and their thresher near the railroad depot on Heustis Street near the Fox River. (Courtesy of Roger Weiss Jr.)

M. E. Church, Yorkville, Ill.

This Methodist church sat on the corner of Madison and Main Streets near the courthouse for 88 years until it burned on February 9, 1947. During the winter, city leaders would close Main Street near the church so children could sled down the hill toward the river. Hydraulic Avenue and the railroad track remained open, so sometimes the children had to bail out of the sleds to avoid oncoming traffic. (Courtesy of Susan Kritzberg.)

Yorkville's original public water source was a springhouse south of town built in 1886, according to *A History of Yorkville, Illinois 1836–1986*. A six-inch wooden main that did not provide enough pressure for firefighters at higher elevations provided the town's water. Water service cost $5 a year per house in 1894, with additional charges for sprinkling a garden or lawn and for a boiler for heating. (Courtesy of Roger Weiss Jr.)

The lightposts on the two-lane concrete bridge spanning the Fox River can be seen in the background of this undated photograph of downtown Yorkville. Webster's Rexall Drug Store, seen on the left, tended to be bustling, as Susan Kritzberg remembers it. "Each day after school, my mom would give me a dime and we could go to the drugstore and get a treat," remembered Kritzberg, a 1973 Yorkville High School graduate, in a 2011 oral history interview for the Yorkville Public Library. "It would have been candy or ice cream or from the soda fountain." (Courtesy of Susan Kritzberg.)

The concrete bridge was built across the Fox River in the late 1920s. An August 18, 1926, *Kendall County Record* article indicates that the detour bridges would probably open within a week, if weather allowed. "The old north side bridge is slowly disappearing and the preparations for the new cement work are taking definite shape," the article states. "The foot walk is being made good use of and soon, driving across the river will be resumed." (Courtesy of Roger Weiss Jr.)

Ray Stroud dressed as a political parade-goer of the past for Yorkville's centennial parade, according to the September 23, 1936, issue of the *Kendall County Record*. Dorothy Gabel was the marshal of the parade, which was held on a Saturday afternoon and concluded with the Yorkville Fire Department hosting a water fight. The centennial celebration itself ended on a Monday evening with a street dance and carnival. (Courtesy of Susan Kritzberg.)

Another form of entertainment for children was the Yorkville Theatre. The theater charged just a dime for children, as seen in this September 1936 advertisement from the *Kendall County Record*. (Courtesy of Susan Kritzberg.)

Yorkville Theatre

10 CHILDREN "Why Pay More" ADULTS **15**

WEDNESDAY-THURSDAY, SEPT. 23-24
Jack London's
"THE WHITE FANG"
Shows 7:30-9:15 Admission 10c-15c

SATURDAY-SUNDAY, SEPT. 26-27
A GIANT 7-UNIT SHOW!
1.—Zane Grey's "Arizona Raiders," Larry Crabbe
2. Popeye in "I Wanna Be a Lifeguard"
3. Oswald in "The Barnyard Five"
4. "Stranger Than Fiction," a Novelty
5. "Shorty at the Seashore," a Monkey Act
6. "The Collie," All About the Dog
7. "Midnight Melodies," a Musical Reel.
Shows 7:30-9:15 Admission 10c-15c
Sunday, Sept. 27 is Family Nite. Bring This Ad.

HERE SHE COMES FOR 3 BIG DAYS
Wednesday, Thursday, Friday, Sept. 30, Oct. 1 and 2
SHIRLEY TEMPLE IN
"THE POOR LITTLE RICH GIRL"
Shows 7:30-9:15 Admission 10c-20c

44

The Nine of '09 baseball team poses outside Yorkville High School, at 201 West Center Street, which was built in 1887. A first grade room was added to the east, along with a bigger assembly area, in 1907, while a gymnasium and west wing were built in 1928. (Courtesy of Thomas Milschewski.)

In the carriage, Vol Atherton and his daughter Marguerite Ament watch a baseball game at a diamond along Van Emmon Street. Decades later, the Lions Club helped build more formal baseball diamonds at Memorial Park, along Game Farm Road, after the school district purchased the property there in 1947. (Courtesy of Thomas Milschewski.)

45

Alvah and Lil Hill, with a little help from a motorized moving van, prepare to move from South Main Street in Yorkville to Geneva in May 1910. Alvah was the son of druggist Fred G. Hill and the brother of A.P. Hill, who owned a store in downtown Yorkville. (Courtesy of Roger Weiss Jr.)

Mary Ellen Barton, age three, poses next to a tree at her family's home, north of Route 34 near what was eventually Countryside Parkway. Her parents, C. Arthur and Carrie Barton, lived on and farmed the land from 1931 to 1952. (Courtesy of Mary Ellen Bushnell.)

Some thoughtful adult snapped this undated photograph of neighborhood children. Pictured, from left to right, are (first row) Johnnie Ray Schneider, Carol Blake, Shirley Philips, Bobby Lindholm, Jackie Fetgatter, and Linda Blake; (second row) Kathy George, Jimmy Talbott, Karen Lindholm, Dale Ament, Sandra Fetgatter, Sandy Schneider, Larry Fetgatter, Carol Anne Sweasy, James Blake, and Carlotta Kussel. (Courtesy of John Schneider.)

The Yorkville High School class of 1909 graduated 16 years after the inaugural class. The class of 1909 was comprised of John Ament, Marguerite Atherton, Lois Boston, Cora Callagan, William Donovan, Marguerite Erving Harris, Anna Fitzsimmons, Myra Ford Galvin, Onia Gooch, Frances Kennedy, Minnie Healy, Ruth Kennedy, Ruth Hill, Robert Manley, Mabel Miller, Roy Normanndi, Ida Mae Penman, Charles Schumacher, Mary Wood Jacobs, Walter Stansel, Frieda Nading Wiserman, and Mabel Whitfield, according to the "Yorkville High School Alumni from 1884 to 2009," compiled by Marvin Lawyer. (Courtesy of Roger Weiss Jr.)

Schoolchildren pose outside Yorkville High School in this undated photograph. Members of the class of 1884 met in the upper rooms of 226 South Bridge Street, but a new school was built on West Center Street in 1887. (Courtesy of Thomas Milschewski.)

A class poses for a photograph inside Yorkville High School in this undated photograph. Wooden portable classrooms were placed at the back of the building from 1922 to 1960. (Courtesy of Roger Weiss Jr.)

A Mr. Jeter is seen here taking a ride. As more Yorkville residents bought cars in the early 1900s, the Carter car dealer built a steep test ramp on West Hydraulic Avenue so drivers could test the vehicles, according to A *History of Yorkville, Illinois 1836–1986*. (Courtesy of Roger Weiss Jr.)

Jawaharlal Nehru, prime minister of India, poses with Carol Peterson Enger during a visit to her family farm, east of Yorkville, in October 1949. Her grandmother Ellen Peterson is seen holding Tommy Peterson's hand to the right. Peterson family lore indicates that Nehru wanted to see an American farm. The US State Department's official itinerary for the trip shows the afternoon of October 26, 1949, was slated for a tour of an International Harvester factory in the Chicago area, according to the Harry S. Truman Library. (Courtesy of the Department of State, Harry S. Truman Library.)

Three

YORKVILLE AT WORK AND PLAY

The commerce that had grown along Bridge Street supported the "bankers' row" of homes along Heustis Street, where the town's elite settled near downtown. However, it was incumbent on the town's residents to build their own cultural and entertainment outlets, too.

The temperance movement hit Bristol and Yorkville with the Red Ribbon Club in May 1878. A red ribbon signified that a man's blood would forever be pure and untainted by alcohol. The temperance clubs built a reading room, which the Woman's Christian Temperance Union of Yorkville managed before handing the reigns to the Yorkville Woman's Club on December 4, 1915. The Woman's Club and its volunteers operated the library until 1965, when the club donated it to the city.

With the local economy long driven by agriculture, the Kendall County Farm Bureau started in June 1920 with an office in the courthouse, an adviser with a touring car, and 1,003 members, most of whom lived in farmhouses without electricity and running water.

The Lions Club helped build athletic fields at Memorial Park, along Game Farm Road, after the school district purchased the property there in 1947. Volunteers brought tractors and construction equipment to level the fields and fill the waterway running through it.

Yorkville's first Boy Scout troop was organized in 1914, about four years after Scouting came from England to the United States. The Yorkville Jaycees, which formed in March 1964, organized sandbox drives and swimming classes at the Polish National Alliance camp pool.

Perhaps the greatest fun for children, though, was the simplest: In the early 1900s, children sledded down courthouse hill, which curved down Bridge Street and sent the more adventurous to the bridge across the Fox River. Later generations sledded or skateboarded down Main Street from Madison Street toward the river. "That was a steep hill and you could go all the way down to the river and out onto the ice," said Leroy "Bud" Thanepohn, a 1946 Yorkville High School graduate, in a 2011 Yorkville Public Library oral history interview. "The city would block off Van Emmon, but if traffic was coming on Hydraulic, you just had to bail out before the railroad tracks."

This two-story, brick building on West Center Street served all 12 grades until Yorkville Grade School was built in 1952. One-room rural schoolhouses were common until the 1950s, so Parkview School attracted mostly town residents for the early grades, while high school students came from as far as 20 miles away. (Courtesy of Thomas Milschewski.)

Yorkville students pose outside the school. The first Yorkville High School students met in the upper rooms of 226 South Bridge Street, but a proper school was built on West Center Street in 1887. Additions were made in 1907 and again in 1928. Yorkville Community High School's enrollment was 214 in September 1935. (Courtesy of John Schneider.)

Superintendent F.C. Thomas is pictured here at his desk. In the late 1930s, Thomas wrote, "The Yorkville Community High School exists for the purpose of assisting all those who enter its doors to grow and develop into individuals who are living the good life. Within its doors will be found knowledge to train the mind; social activities to develop the personality, character and ability of people to live together; physical activities to assist in the maintenance of a healthy body; and the arts and religious instruction to develop the emotions and soul." (Courtesy of John Schneider.)

This undated class photograph includes Robert Ohse, who is sitting in the first row on the far left.

Sitting two seats to the right of him is Gordon Schobert. (Courtesy of John Schneider.)

Yorkville High School first organized baseball teams, followed by basketball teams. The first basketball team competed in 1910–1911. This team photograph is undated. (Courtesy of John Schneider.)

The Yorkville High School marching band is not quite in a proper formation in this photograph from the late 1930s or early 1940s. Note the school's name displayed on the skirts of the majorette uniforms. (Courtesy of John Schneider.)

Ruth Sherman (left) and Eunice Christian pose in their marching band majorette uniforms. Sherman married John Schneider on June 21, 1941, not long after she graduated from Yorkville High School, and the couple spent most of their married life in Yorkville. (Courtesy of John Schneider.)

Leroy "Bud" Thanepohn, who would later serve as Yorkville's mayor, sits second from the right in the first row of this school band photograph from 1945–1946. In the back row, second from the right, is Charles "Dick" Ellis, who Dennis Hastert would mention in his autobiography as the guidance counselor who ushered him into Yorkville High School's principal's office when he was searching for a teaching job. (Courtesy of Mary Ellen Bushnell.)

The tumbling club of 1947–1948 poses for a photograph. The club includes, from left to right, (first row) Shirley Backhoff, Loretta Coleman, Alice Fitch, and Yvonne Perkins; (second row) Vera ?, Leona Thompson, Jean Dickson, Mary Ellen Larson, Lois Glenn, and Barbara Lyon; (third row) three unidentified people, Lauradell Lyon, Norma Ehrhardt, and Mary Ellen Barton. (Courtesy of Mary Ellen Bushnell.)

In the 1940s, one cheerleading team encouraged both the football and basketball teams. The cheerleaders for the 1947–1948 academic year are, from left to right, Mary Ellen Barton, Yvonne Perkins, Norma Ehrhart, and Loretta Coleman. (Courtesy of Mary Ellen Bushnell.)

Yorkville's cheerleaders for the 1946–1947 academic year pose for this photograph. They are, from left to right, Marian Griswald, Yvonne Perkins, Mary Ellen Barton, and Rebecca Miller. (Courtesy of Mary Ellen Bushnell.)

After his football career ended in 1934, Harold "Red" Grange kept polo ponies at the Schneider family farm. He is pictured here with John Schneider (middle) and Fred Schneider (right). Dubbed the "Galloping Ghost," Grange played for the University of Illinois and the Chicago Bears. (Courtesy of John Schneider.)

John Schneider sent this photograph, taken after basic training, to his "dearest with lots of love," signing it, "Johnnie." Schneider married Ruth Sherman on June 21, 1941, not long after she graduated from Yorkville High School. He was drafted into the Navy while working for Lyon Metal and taking correspondence courses on refrigeration, so he had Ruth forward the class materials to him while he was in the service. (Courtesy of John Schneider.)

This photograph shows a young Frank F. Weber, who was born on November 23, 1886, in Millbrook. As an adult, he had a newsstand and confectionary on Van Emmon Street that doubled as a waiting station for local trolleys. Later, he moved his business to the McHugh Building, on the east side of Bridge Street. Upon his death, he is described in the October 23, 1958, issue of the *Kendall County Record* as a "cripple who could get about only with difficulty." Weber invented the "cold dog," which was ice cream dipped in chocolate and served on a stick. "Mr. Weber was almost always cheerful and willing to exchange with anyone who stopped in to see him," the article states. "Folks often wondered how he could be so cheerful and full of humor." He died at age 71, leaving behind a sister, a brother, and nieces and nephews. (Courtesy of Roger Weiss Jr.)

This 1923 Gray automobile advertised Frank F. Weber for president in 1940. Weber had a business on the east side on Bridge Street, but he did not make it far, if at all, at the June 1940 Republican convention. The top GOP candidates before the convention were Wendell Willkie, Robert A. Taft, and Thomas E. Dewey. Willkie captured the nomination, although Dewey won the Illinois primary. (Courtesy of Roger Weiss Jr.)

These banners strung across Bridge Street in the mid-1920s are celebrating the Fourth of July. A hitching post for horses sits along the sidewalk on the right side of the photograph. (Courtesy of Barry J. Lauwers.)

After dabbling for a couple years in refrigeration service, John Schneider rented this building from 1950 to 1952 to open a store. Then, one day while he was working on refrigeration equipment in Fred Ohse's grocery store, Ohse surprised Schneider by offering to let him buy his building for no money down. Schneider accepted and moved to the east side of Bridge Street, north of Hydraulic Avenue, a few months later. (Courtesy of John Schneider.)

The George Ohse grocery store sat on the west side of Bridge Street. Fred Dickson remembers clerks gathering and wrapping items from shopping lists patrons presented them. "Everything was cash in those days, but a lot of them ran credit," Dickson said in a 2011 oral history interview. "They would reach underneath if they had credit . . . They had little folders with order blanks." (Courtesy of Barry J. Lauwers.)

Clair Munson and Ernie Zeiter operated a barbershop in downtown Yorkville. Pictured, from left to right, are Munson, Leo Scott, Zeiter, and Frank Martyn. Martyn served as Yorkville's police chief from 1940 to October 1966. (Courtesy of Barry J. Lauwers.)

Clair Munson (standing, left) and Ernie Zeiter (standing, right) pause for a photograph with unidentified patrons. Munson's nephew Barry J. Lauwers later took over their business. (Courtesy of Barry J. Lauwers.)

Just a block away from Yorkville's bustling downtown, Heustis Street housed spacious homes with comfortable yards for many of Yorkville's elite. Dr. Robert A. McClellan, who lived at 406 Heustis Street with his family, was a local physician from 1878 until he died in 1919. He was elected coroner in 1880, sometimes hosting funerals of well-known family friends at his house, and he served two terms as mayor until 1916. (Courtesy of Richard and Andrea Speckman.)

Dr. Lyman Perkins (1877–1960) served as coroner between 1940 and 1956. He was also a physician who was active with the Lions Club and the Masonic Lodge. (Courtesy of Roger Weiss Jr.)

Pearl Marshall was fondly remembered by children who lived near her on Heustis Street as a lady who kindly gave them her red raspberries. She married Hugh Marshall, son of *Kendall County Record* founder John R. Marshall, and moved with him to Yorkville in 1908. The couple had two sons, John and Robert. She died November 30, 1946, at age 69. (Courtesy of the family of Carolyn Schulter O'Hare.)

Carolyn Schulter poses with her basket on Easter. Her family moved into a house and carriage house on Heustis Street that Robert A. McClelland built as his daughter's wedding present in 1878. Soon after the Schulter family moved there in 1922, the carriage house was converted into a home for Carolyn's father's parents. Seen behind her is the home of Dr. Frank G. and Mildred G. Loomis. Dr. Loomis served as the town veterinarian. (Courtesy of the family of Carolyn Schulter O'Hare.)

Christopher Myland "Mike" Schulter poses in the driveway of his family's Heustis Street home in August 1941, the month of his 11th birthday. When he was younger, he and his sister Carolyn played "Tom and Mary," their version of Cowboys and Indians, while pretending the bottom steps of the home's spiral staircase were a covered wagon. (Courtesy of the family of Carolyn Schulter O'Hare.)

Above, from left to right, Christopher "Mike" Schulter, Carolyn Schulter, ? Glawe, Clarence Schulter Jr., ? Glawe, and Betty Glawe pose in front of the Schulter home near the Fourth of July holiday. Clarence Schulter Sr. had bought the American flag from the City of Galena, and the family had a tradition of draping it from the second-story roof and over the porch on Independence Day. (Both, courtesy of the family of Carolyn Schulter O'Hare.)

Katherine (left) and Mathias Schulter, known as "Nannie" and "Grandpa" to Carolyn Schulter, are seen here relaxing on a bench. If one looks closely enough, he or she can see that the headline of the newspaper mentions "Nazi Secrets." (Courtesy of the family of Carolyn Schulter O'Hare.)

Clarence Schulter Jr. (second from left) plays with an unidentified neighbor as Emma Ebeler (far right) and Katherine Schulter look on. Carolyn Schulter believed her mother and grandmother favored Clarence, whom the family called Tootie in his youth. (Courtesy of the family of Carolyn Schulter O'Hare.)

Dr. Stanley and Elsie Berg, seen below in December 1947, bought Carolyn Schulter's grandparents' house, which had once been the carriage house associated with the younger Schulters' home. Sometime later, a distinctive wagon wheel fence was installed at the house. (Both, courtesy of the family of Carolyn Schulter O'Hare.)

Mike (left) and Carolyn Schulter play in front of the Schulter home, which was about 75 years old when the family bought it in 1922. The family lived there until 1946, when they moved to St. Louis. (Courtesy of the family of Carolyn Schulter O'Hare.)

This undated photograph shows the former carriage house on Heustis Street that was remodeled into a house for Katherine and Mathias Schulter. "Theirs was a cozy house, and while it did not have a lot of rooms, what rooms there were were quite large and airy," their granddaughter Carolyn Schulter O'Hare writes in her memoirs. (Courtesy of the family of Carolyn Schulter O'Hare.)

From left to right, an older Clarence Schulter Jr., Carolyn Schulter, Edith Schulter, and Clarence M. Schulter Sr. pose in front of Clarence Sr.'s parents' home. Carolyn went on to have four children, marry and divorce James O'Hare, and work as a parish secretary for the St. Louis Cathedral Parish. (Courtesy of the family of Carolyn Schulter O'Hare.)

Children play at the Polish National Alliance Youth Camp, just west of Yorkville on River Road. This picture postcard is postmarked 1946. (Courtesy of Roger Weiss Jr.)

Linda Johnson sits on a dock at Harris Forest Preserve around 1969. By 2014, the preserve included seven picnic shelters, a lake, a horse arena, a baseball diamond, and a sled hill on 90 acres south of Route 71 and west of Route 47. (Courtesy of Joanne K. Leibold.)

Mature trees line the sidewalk in this photograph with a view looking east at 505 and 507 West Ridge Street, taken before 1921. Yorkville's population billowed to 1,568 in 1960 and then 16,838 in 2008. (Courtesy of Roger Weiss Jr.)

Walnut Lodge was among several campsites and lodges just outside Yorkville. Note the train speeding along the tracks next to the Fox River. (Courtesy of Jeff Scull.)

John Schneider, during Yorkville Public Library's 2011 oral history project, remembers one of his first jobs—collecting tickets at the local theater, which can be seen to the far left on Van Emmon Street. "They had stage shows once in awhile," he said. "When they had a silent movie, there was a lady who played the piano." (Courtesy of Barry J. Lauwers.)

Beatrice Smith stands next to her parents' restaurant, Allen's Restaurant, at the northwest corner of Bridge and Van Emmon Streets. Behind her are Van Emmon Street and the Muellner Building, which was demolished in October 2012. Born on Christmas Eve, 1921, Smith died in January 2013 in Aurora. (Courtesy of Tom Smith.)

Edward (left) and Edith Allen stand at the back of their business, Allen's Restaurant, with the building at the northeast corner of Bridge and Van Emmon Streets in the background. Edward Allen and the former Edith May Hill were both born in England, she in 1893 and he in 1879, and they operated the restaurant in Yorkville for decades. (Courtesy of Tom Smith.)

An unidentified woman stands near the Allen's Restaurant sign along Bridge Street. The restaurant became the Bee Hive Café when its founders' daughter Beatrice Smith took over in the late 1950s. (Courtesy of Tom Smith.)

Christine A. Weiss rides Lady, a white horse, in a parade down Bridge Street in 1968 or 1969. She eloped with Roger Weiss on October 8, 1940, which was her 22nd birthday. Christine served as Kendall County Animal Control's dog catcher for about 40 years, retiring in 1995, according to her obituary. She was born in 1918 in Maple Park. (Courtesy of Susan Kritzberg.)

This convertible carries the class of 1970's homecoming court in 1969 past Baird's jewelry shop and the Barley Fork restaurant on Bridge Street in downtown Yorkville. In that era, homecoming festivities started on Friday night with the junior varsity football game, a bonfire on school grounds, and a party in the basement of the Chapel on the Green hosted by the Foxes Lair Club. On Saturday, the homecoming parade downtown was followed by the varsity football game and the dance. (Courtesy of Susan Kritzberg.)

Susan Harberts (left) and Barb Hopkins pose in downtown Yorkville in 1971, two years before they graduated from Yorkville High School. During that time period, Haggerty's was a typical small-town department store that offered jeans, overalls, work boots, toys, makeup, fabric, and similar items. (Courtesy of Susan Kritzberg.)

The Haggerty family, who owned Haggerty's department store downtown, visit with their grandchildren. Pictured, from left to right, are Brent Haggerty, John Leibold, Frank Haggerty, and Libby Haggerty. (Courtesy of Joanne K. Leibold.)

Before Bridge Street and its bridge over the Fox River were widened from two lanes to four, the downtown district had plenty of room for angled parking. The 1984 bridge expansion project meant removing buildings on the east side of the street near the river, but the Dickson Building, visible here on the west side of the street (the most distant building on the left) near the river, was spared, and it remains standing today. (Courtesy of Barry J. Lauwers.)

The Barley Fork restaurant had a fork more than 100 years old hanging from a ceiling beam when George Lane and his wife opened it in July 1942. "A visit to the premises last Friday revealed a splendid, immaculate setup for serving meals and ice cream dishes," an article in the July 22, 1942, issue of the *Kendall County Record* states. "Some novel ideas will be introduced, among them a basket lunch and barley soup." (Courtesy of Susan Kritzberg.)

The former Pizza Place building, at 205 South Bridge Street, was destroyed in a fire on February 14, 1977, with part of the roof collapsing. Some water seeped through a crack in the wall at Yorkville Appliance & Furniture Store, while the Fashion Shop, at 203 South Bridge Street, saw both smoke and water, according to a February 17, 1977, *Kendall County Record* article. (Courtesy of the Bristol-Kendall Fire Department.)

Gene Harberts operated fee fishing ponds on his property at Game Farm Road and Route 34. He moved to Yorkville as a teenager in 1932 and built his home at what was then the northwest edge of town in 1950. Gene and his wife, Irene, opened a television and radio sales and service store in 1960 near the southeast corner of Bridge Street and Hydraulic Avenue. (Both, courtesy of Susan Kritzberg.)

Four

PUSHING FOR PROGRESS

In his autobiography, Dennis Hastert describes hoisting the 1976 Class A state wrestling championship trophy as "among the finest moments in my life." An Oswego native who taught government, history, and economics at Yorkville High School for 16 years, Hastert coached wrestling before launching a political career that would culminate with him being the longest-serving Republican Speaker of the House, a position he held from 1999 to 2007.

As a coach, his first state wrestling champion was Gary Matlock, at 112 pounds in 1973. Three years later, the Foxes capturing the team state title at Assembly Hall at the University of Illinois in Urbana-Champaign was a community event. "You could have shot a cannon down Yorkville's main street and not hit anyone at state tournament time because everyone showed up at Assembly Hall," Hastert states in his autobiography.

And just as Hastert grappled his way to Washington, DC, Yorkville combined with its neighbor to the north in 1957 and continued expanding. Yorkville Grade School was built in 1952, a new high school opened next door in 1959, and Circle Center School opened in 1967. The Bristol-Kendall Fire Protection District built a three-bay station at Route 47 and Fox Road in 1952. A year later, the Congregational church added classrooms and a fellowship hall. The Model Box factory opened a couple blocks off the downtown business district in 1950, and the Countryside Center opened on the northwest corner of Routes 34 and 47 in 1972.

State officials slowly pieced off the game farm it had opened in 1928. The first section was transferred to the city in 1979 for the Beecher Community Center and the Yorkville Public Library. In 1987, the game warden's four-bedroom house went to the city, which used it as a police station from 1995 until 1999. The rest of the game farm went to the school district in 1992.

After Yorkville and Bristol combined in 1957, the Lions Club helped bring home mail delivery to the area by installing street signs. At least one throwback to the twin villages remains, though: Yorkville has two Main Streets.

This aerial photograph, taken around 1960, shows Game Farm Road south of Route 34. Since then, a combined city hall and police station, a library, two schools, and a slew of homes have been built in what appears here as open space. (Courtesy of Susan Kritzberg.)

Sisters Kay and Jo Ann Peterson pose outside Yorkville Grade School, which was built in 1952. Less than a decade after it opened, the school suffered about $55,800 in damages in a fire, according to *Kendall County Record* news articles. A neighbor looked out her window at about 11:00 p.m. on March 30, 1961, to see flames spewing from the roof of the school, which some had claimed to be fireproof. (Courtesy of Jo Ann Gryder.)

Sheriff William Hayden poses outside the fire department at Route 47 and Fox Road shortly after it was built in 1952. The Bristol-Kendall Fire Department started as an independent entity supported by stockholders, with the first call recorded on January 27, 1922, at the A.P. Hill store. For some time, the department operated out of Bert Almay's residential garage, at West Main and King Streets, before moving to East Hydraulic Avenue and then to this fire station. (Courtesy of the Bristol-Kendall Fire Department.)

The equipment lined up outside the fire department includes an ambulance that resembles a hearse, as was customary at the time. This photograph was taken between 1955 and 1970. (Courtesy of the Bristol-Kendall Fire Department.)

The fire engine displayed on the far right is a 1955 American LaFrance truck, which Bob Fleckinger restored after it was taken out of service. Today, the restored engine is on display at the Bristol-Kendall Fire Protection District's Station 1, at 103 East Beaver Street. (Courtesy of the Bristol-Kendall Fire Department.)

In 1964, the Bristol-Kendall Fire Department includes, from left to right, (first row) George K. Cies, Ray Schneider, Dave Erickson, and Dan Hannon; (second row) Charles Stading, Scott Miller, Harlan Wiley, LeRoy Coleman, Dick Behrens, and Bob Prickett; (third row) Max Riemenschneider, Ron Leifheit, chaplain Bruce Salter, Chief Ralph Blake, First Assistant Chief Win Prickett, Lawrence Gardner, Verne Riemenschneider, and Frank Sharp; (fourth row) Ted Wilkinson Sr., Gordon Wilson, Bobbie Green, Robert Skinner, Blaine Harker, Ellsworth Windett, Vic Smith, Roger Weiss Sr., and John Behrens. (Courtesy of the Bristol-Kendall Fire Department.)

Yorkville's train depot sat in a small building south of the railroad tracks in 1962. The Fox River branch of the Chicago, Burlington & Quincy Railroad hosted the first train in that area in October 1870. (Courtesy of Roger Weiss Jr.)

From left to right, an unidentified man, Laurence "Bud" Henning, Eugene "Gene" Harberts, and another unidentified man pose after hunting Canada geese in the late 1950s. Harberts ran a television and radio sales and service business, while Henning was president of the Yorkville National Bank. Henning taught at Yorkville High School for two years before spending 35 years at the bank, starting in 1951. He died in July 2013 at age 88. (Courtesy of Susan Kritzberg.)

A sheriff's squad car is parked outside the Kendall County Courthouse. The addition was built around 1960, and, after the courts moved to a new campus on the western edge of Yorkville in 1998, a restoration project finished in 2001 included dying the red bricks in the two extensions to more closely match the original section's tan bricks. (Courtesy of Roger Weiss Jr.)

Bonnie Willman (later Marx) rides her bike outside the Kendall County Courthouse, which sat across Madison Street from the county jail. Her father, Frank Willman, served as sheriff from 1958 to 1962, which meant his family lived in the sheriff's quarters attached to the county jail. Sheriffs were not allowed to succeed themselves then, so he served a four-year term as county treasurer next. In that era, local leaders typically played a variety of roles, as there were only so many people available to serve, Bonnie Marx said decades later. "He'd change his pants and jacket and a shirt and tie, and he was the treasurer," Marx remembered. (Courtesy of Bonnie Marx.)

87

Bonnie Willman poses inside one of the Kendall County Jail cells while her father was sheriff. Outside of his public service, Frank Willman operated Kendall Plumbing & Heating Co. for about 25 years, starting in 1955, with his brother Arthur. He also developed the 85-home Fox Lawn subdivision and was on the Bank of Yorkville's board of directors for 15 years. (Courtesy of Bonnie Marx.)

Kendall County sheriff Frank A. Willman (left) and Ralph "Burky" Burkhart of Burkhart's Garage in Oswego pose for a photograph as Burkhart hands him the keys to a squad car. Willman served as sheriff from 1958 to 1962. (Courtesy of Frank Willman.)

Frank A. Willman (center) and Norman "Toomey" Burson (right) sit in a boat, shocking the fish to see how many remained in the pond at the end of Bonnie Lane. Burson, who was born on August 25, 1912, in Plano, was a conservation police officer for 25 years and a Kendall County sheriff's deputy. The man standing in the rear of the boat is unidentified. (Courtesy of Bonnie Marx.)

The Bristol-Kendall Emergency Medical Service was established in 1981. It operated out of a building at 1203 North Bridge Street near Landmark Avenue. (Courtesy of the Bristol-Kendall Fire Department.)

The Chapel on the Green sits off Town Square Park at 107 West Center Street. The Bristol Congregational Church built the structure in 1855 with $600 from members and a $300 loan, according to *A History of Yorkville, Illinois 1836–1986*. (Courtesy of Barry J. Lauwers.)

The Yorkville Congregational Church celebrates the installation of Rev. David E. Bigelow as minister. Pictured, from left to right, are (first row) all unidentified; (second row) Jeaness Medin, Mary Ellen Walker, Kathy George, Sheila Hodge, Julie Shuler, two unidentified people, Isabell Harris, Althea Johnston, and Mary Doetschman; (third row) Vincent Clark, Dave Doetschman, Jerry Hanson, unidentified, Frank Harris, two unidentified people, LaVerne Hanson, and Charles Doetschman. (Courtesy of the Yorkville Congregational United Church of Christ.)

Crews raise the north wall of Heritage Hall, which was the northern addition to Chapel on the Green in the 1950s. The members of the Congregational and Baptist churches combined to form the Yorkville Federated Church on January 18, 1920, but, almost four decades later, the Baptist membership declined enough that the congregation voted to return the name to the Yorkville Congregational Church in 1959. (Courtesy of the Yorkville Congregational United Church of Christ.)

Crews work to add the two-story Heritage Hall in 1953. The project, initially estimated to cost $40,000, added educational rooms, a women's parlor, modern restrooms, a kitchen, and a unified heating system, among other things, according to *A Church and Its History: Yorkville Congregational Church, 1834–1984*. (Courtesy of the Yorkville Congregational United Church of Christ.)

Adding Heritage Hall meant raising the building to make room for a basement. Earlier photographs of the building do not include the three front steps that are visible in later photographs; they were added during this project. (Courtesy of the Yorkville Congregational United Church of Christ.)

Crews work to add the two-story Heritage Hall about 1953. Ira Perkins and Homer Dickson supplied many of the materials for the expansion, while several church members completed the work, according to *A Church and Its History: Yorkville Congregational Church, 1834–1984*. (Courtesy of the Yorkville Congregational United Church of Christ.)

The Yorkville Congregation Church's kitchen crew poses for this undated photograph. Pictured, from left to right, are (first row) Carolyn Schultz, Julie Cies, Naomi Riemenschneider, Sheila Hodge, Barb Johnson, Kathy Roach, Donna Sherwin, Lois Ament, Mae Houck, Alberta Sharp, Joyce Schlapp, and Pat Stewart; (second row) Helen Shick, unidentified, Betty Jo Beecher, Rita Reim, Jean McKeever, Lenora Cornils, Julie Hanson, unidentified, and Ruth Farren. (Courtesy of the Yorkville Congregational United Church of Christ.)

Lois Ament walks down the front steps of the Yorkville Congregational Church as Rev. Pat Flynn shakes Renee (Ament) Wilson's hand. Reverend Flynn served as interim minister after the popular Rev. Lawrence J. Rezash's tenure from 1971 to 1982. (Courtesy of the Yorkville Congregational United Church of Christ.)

On February 8, 1944, Joyce Reinboldt married Lt. J. Dean Schlapp in a candlelight ceremony at the Yorkville Federated Church, later known as the Chapel on the Green. The bride wore a white satin dress and a lace-edged fingertip veil, along with a circlet of white roses. Her bouquet was white roses and gladiolas. (Courtesy of Gail S. Gaebler.)

Joyce and Dean Schlapp's daughter Gail Joyce Schlapp married Frederick John Gaebler III in the same church on June 15, 1970, a Monday evening. She wore a silk organza gown with a high neckline and empire waist. Her cascade bouquet had Eucharist lilies, stephanotis, and ivy. (Courtesy of Gail S. Gaebler.)

Dennis Hastert built the wrestling team into a program that won the state title in 1976. In the first row, third from the right, in this 1978 team photograph is Mickey Torres, who placed fourth in the state at 98 pounds in 1976. Other members of the 1976 state championship team were Curt Williams, second at 126 pounds; Terry Robbins, fourth at 155 pounds; Joe Cusic, second at 132 pounds; Larry Patrick, first at 119 pounds; James Blackford, semifinalist; Dave Torres, first at 112 pounds; Scott Corwin, first at 105 pounds; and Chuck Harbin, third at 145 pounds. (Courtesy of Dennis Hastert.)

Dennis Hastert (right) is seen here scooping ice cream at Yorkville's Fourth of July celebration. He was active with the Kendall County Republican Party and served three terms in the Illinois General Assembly before being elected to the US House of Representatives in 1986. In the Illinois General Assembly, he promoted legislation on child abuse prevention, property tax reform, education, and economic development. (Courtesy of Joanne K. Leibold.)

The Bristol-Kendall firefighters hosted water fights during the Yorkville Fourth of July celebrations, near Town Square Park, for decades. Shown here are, from left to right, Brian Thanepohn, Dan Reinboldt, and Jim McCarty. (Courtesy of the Bristol-Kendall Fire Department.)

Dennis Hastert was Speaker of the US House of Representatives during the terrorist attacks of September 11, 2001. He was finishing a routine doctor's appointment when he learned that either a small plane or a helicopter had struck the World Trade Center's north tower, according to his autobiography. After he had a more accurate account, he wanted to hold a prayer on the House floor and adjourn, but, before he could, security whisked him away out of fear of an attack on the Capitol. He later helped pass legislation to prevent terrorism and to create the Department of Homeland Security. (Both, courtesy of Dennis Hastert.)

Five

A New United City of Yorkville

During an oral history interview for the Yorkville Public Library in September 2011, Leroy "Bud" Thanepohn said, "Growth pretty much comes naturally, so we'll have continued growth and through it all you just have to hope that good citizens will step up and are willing to serve the greater community to the best of their ability. I don't regret growth and changes, because that's just going to happen. You just have to do your part in directing it and hope you can guide it in a way that reflects our moral, social and religious values."

Individuals might debate whether population and economic growth happen naturally, but it undoubtedly happens. Kendall County's population grew from 7,730 in 1850 to 39,413 in 1990, according to the US Census Bureau. At the heart of Kendall County, Yorkville's growth was astonishing in more recent decades, ballooning from 3,925 people in 1990 to 16,838 in 2008.

Thanepohn became mayor in 1975, about 15 years after the 1960 census found Yorkville was the second-largest city in Kendall County, at 1,568 people. Thanepohn took office about six years after Pearl Harbor survivor Nick Moisa led a committee with American Legion Post No. 489 to build the veterans memorial at Town Square Park. He was sworn in three years after the Countryside Center and the Fox Industrial Park opened on opposite sides of the city.

During Thanepohn's tenure in city government, he helped start the Yorkville Chamber of Commerce, in 1971, to help regenerate downtown. City leaders also began paving the oil-and-chip streets in town, worked with school leaders and community fundraisers to add lights at the school tennis courts, and cleaned up the area around the dam. They banned parking north of the dam to discourage nonresidents from littering and trampling residents' property. On the dam's south side, they built Bicentennial Riverfront Park over a longtime dump.

"We dragged a nearby island to shore to cover all of the dump," Thanepohn said. "So in 1975 we developed the first park in Yorkville since 1849, which was 126 years before we had a new park."

Perpetual Flame Torch

Designed by Ambrose Trippon

Built by Henry Lippman, Prescrete Corp.

26" HIGH

ARTIST' DRAWING AND TORCH HEAD NOW ON DISPLAY AT THE YORKVILLE NATIONAL BANK

SPONSORED BY AMERICAN LEGION POST 489

Dedication May 30 at Yorkville City Park
3:00 p.m. by Honorable Charlotte Reid

---- Donations are being accepted ----
At Yorkville National Bank Or May Be Mailed To
Project Chairman Nick Moisa,
American Legion Post 489 Yorkville 60560

A bronze plaque will be inscribed with names of all who gave their lives in all wars.

A Flag and Pole Donated by the City of Yorkville will also be Dedicated

FAY'S CATERING SERVICE will serve their Famous Barbeque Chicken at the Park

Nick Moisa, who headed American Legion Post No. 489's effort to build the eternal flame monument at Town Square Park, strides forward during the monument's public dedication in 1969. Also pictured below, from left to right, are an unknown Legionnaire, state senator Robert Mitchler, and state representative Charlotte Reid. An East Aurora High School graduate, Moisa was a sailor on the USS *Nevada* when the Japanese attacked Pearl Harbor on December 7, 1941, and he told his daughter Sandy Whiteis decades later that he remembered seeing the smiling faces of Japanese pilots as they bombed American ships, according to an October 30, 2001, article in the *Beacon-News*. He wanted to have a 30-foot monument in Yorkville's signature park memorializing Kendall County veterans who died in wars. (Both, courtesy of Sandra Whiteis.)

Since then, the monument has provided a backdrop for Memorial Day and other important services in Yorkville. Nick Moisa, pictured here, was also instrumental in helping the American Legion fix the monument after the gas flame mechanism stopped working about 25 years after its dedication. Moisa also operated Pine Village Steak House and Vat and Vine Liquors before serving as a Kendall County Courthouse bailiff in his retirement. He died on October 29, 2001, leaving behind two children, Sandra Whiteis and Nicholas T. Moisa, as well as four grandchildren and several great-grandchildren. (Courtesy of Sandra Whiteis.)

The Pine Village Steak House, at the southwest corner of Routes 34 and 47, was the scene of five gruesome murders around 10:00 p.m. on December 29, 1972, when Carl Allan Reimann opened fire after they stole $649.71 in cash and checks. As *Kendall County Record* reporter Tony Scott details in a December 27, 2007, article, Reimann's victims were "Dave Gardner of Yorkville, a 35-year-old grocery store manager and father of four who was sitting at the Pine Village bar waiting to pick up food to bring home to his family; Robert E. Loftus of Bristol, a 48-year-old Naval veteran and bar patron; Catherine Rekate, 16, a Yorkville High School junior working part-time at the restaurant as a dishwasher; George Pashade, 74, a German immigrant and Aurora resident who worked as the restaurant's chef; and John Wilson, 48, of the North Aurora, the bartender." Reimann and his girlfriend, Betty Frances Piche, were apprehended in Morris, and their May 1973 trial was held in Winnebago County. Piche was released from prison in 1984, while Reimann is serving his sentence of 150 years for each victim at Dixon Correctional Center. (Courtesy of Sandra Whiteis.)

The Yorkville Y Mart grocery store sustained more than $100,000 in damages in a fire on Easter Sunday, 1970, according to an April 2, 1970, article in the *Kendall County Record*. A nearby service station attendant saw heavy black smoke pouring from the roof at 4:37 p.m., and firefighters battled the blaze for more than five hours. "At the height of the blaze, aerosol cans literally 'flew' out of the building and exploded from the intense heat," the *Record* article states. At the time, John Dailey operated the meat market, while Pete and Ted Demetralis operated the grocery. After the fire, police guarded the liquor store, which suffered little damage aside from broken windows, to prevent looting. The building, which sat at the northeast corner of Routes 34 and 47, was torn down in December 1985. (Both, courtesy of Floyd Anderson.)

An eastbound freight train carrying silica sand derailed about 11:30 p.m. on Thursday, July 23, 1970, sending sand and 25 railcars around Yorkville's downtown. A railcar knocked out a bedroom wall in an empty second-floor apartment of the Wunsch Building on Hydraulic Avenue. The first-floor clinic pharmacy, the clinic, and Dr. Joseph Gruber II's office also were damaged. By Tuesday morning, the scene was cleared enough for most normal activity to resume. (Courtesy of Floyd Anderson.)

Everett Hauge (left) was among throngs of residents who surveyed the damage. "Most of the cars in the train were hauling silica sand and the weight gave the cars momentum as they left the tracks," a July 30, 1970, *Kendall County Record* article states. "Some dug in as deep as the wheels. On other cars, the trucks were sheared off. Rails were twisted and ties were shredded like match sticks." (Courtesy of the family of Christine Borneman Hauge.)

Jeff Beach (not pictured) remembered having a backyard campout with a friend the night of the derailment. They had stuck pennies to the tracks with chewing gum earlier that day and worried that had caused the massive derailment. "We had placed them way west of where the derailment occurred as we found them paper-thin later that day when we were surveying the scene," Beach later recalled. "Luckily, it was mostly silica sand in the rail cars, so no major hazards occurred." (Both, courtesy of the family of Christine Borneman Hauge.)

The cleanup required large machinery, according to a July 30, 1970, *Kendall County Record* article. "Early Friday morning specialized railway emergency crews were on the scene with huge tractors," the article states. "They pulled and dragged the overturned cars off the roadbed and cleared the way so other crews could begin laying new track. As the new track was laid, huge cranes moved in and removed the wrecked cars." (Both, courtesy of the family of Christine Borneman Hauge.)

Carolyn Hauge Taylor is seen walking on the tracks near the Yorkville post office. Her grandmother Louise Borneman lived across the street from the post office but was so hard of hearing she did not wake up when the train derailed, Taylor said. "When she woke up in the morning, she wondered why there were people in her yard," Taylor said. "She went outside to see what had happened." Another area resident might not have had such an innocuous experience had she not moved about six months earlier. In February 1970, Gail Richards (not pictured) moved out of the second-floor apartment damaged by a train car. "When I lived there, I was always terrified the train was going to drive right through my window," Richards wrote decades later. (Above, courtesy of the family of Christine Borneman Hauge; below, courtesy of Floyd Anderson.)

109

Bob Wunsch (not pictured) was a 21-year-old living in a second-floor apartment in a building owned by his father, Dr. Lloyd A. Wunsch, at the time of the derailment. "We were awakened by the train hitting the apartment next to ours and the air was full of silica sand as if we were living in a dream," Bob wrote decades later. "We realized what had happened and left the building with Bristol-Kendall Fire Department via the rear fire escape." Meanwhile, Floyd Anderson and his wife, Sherry, were driving east on West Hydraulic Avenue and turned onto Main Street. "I turned in front of the train," Anderson remembered years later. "Had I waited for the train, we would have been directly involved in the derailment. I believe in guardian angels." (Both, courtesy of Floyd Anderson.)

Within a week of the derailment, the first-floor clinic pharmacy was reopened. Patrons had to use one of the doors of the attached clinic instead of the main street entrance, according to an article in the July 30, 1970, issue of the *Kendall County Record*. (Courtesy of Floyd Anderson.)

Countryside Center sat northwest of Routes 34 and 47 between 1972 and 2006, when it was leveled as part of a redevelopment plan that later collapsed. The center became a second downtown; it had men's and women's clothing stores, casual and fine dining, a movie theater, and a bank. Safari Market featured stuffed and mounted animals, including a polar bear and an elk, displayed in the grocery story, and Hornsby was a department store where one could buy everything from bicycles to lawn equipment to pets. Jerry Bannister remembers buying his first baseball mitt at Hornsby, and Countryside Center's open spaces hosted public performances and provided a hangout for children and teens. "I remember my grandpa getting me my first bike at Hornsby's, which was very special since as the youngest of five, I usually had hand-me-downs," said Rosie Subat Ralston, who graduated from Yorkville High School in 1996. "Countryside also is the setting of my first date with my now husband for the Fourth of July fireworks [in 1999]." (Courtesy of Robert P. Corwin.)

The Countryside Center's open space hosted craft shows, concerts, and other events, including the high school homecoming bonfires and street dances. At times, children were discouraged from skateboarding or riding their bikes there. Patti Mann remembered her son finding a golden egg during an Easter egg hunt there and winning a gift certificate to a department store at the center. Aimee Walters Long said she worked at Radio Shack with John Purcell and John Hart. "We would put batteries in the remote control cars and race them up and down the store. We just explained to Ted Shick that we were testing the products for quality," Long said. (Both, courtesy of Robert P. Corwin.)

The 158,000-square-foot open-air shopping center did not have an entrance off Route 47, but it had about 40 tenants in July 2002 when Virginia Purcell and Robert Corwin sold the center to Harold and Rebecca Oliver, who owned Mason Square Shopping Center in Oswego, according to a July 11, 2002, article in the *Beacon-News*. The Olivers originally wanted to spend about $2 million and two years renovating the center Purcell's husband, Jack, built in 1972. "After most of the shops had closed, I remember as a kid going in there and feeling like I came across the secret garden of shopping centers," said Darlene Niesen. "You could tell it was thriving at one point, and it unfortunately never reached its full potential." (Above, courtesy of Robert P. Corwin; below, courtesy of Cara Behrens.)

The Safari Market, while locally operated, had the feel of larger, chain supermarket, Randy Ray Scott wrote decades later. "You had to drive up to pick up your groceries or take them to the car yourself," Scott remembered. "Safari did have a drawing each week for cash." (Courtesy of Jo Ann Gryder.)

Safari Market meat cutters gather for a group shot. Pictured, from left to right, are Gregg Molina, Jim Tunnell, Barney Johnson, Walt Johnstone, and Andy Schleiter. (Courtesy of Walt Johnstone.)

Bruce Morrison (left) and John Nelson worked as meat cutters at Safari Market about 1969 or 1970. As a nod to its name, the store featured stuffed and mounted animals. "When I was a kid, I thought taxidermy animals were normal in grocery stores because of Safari," Nathan Ament remembered years later. "It took out-of-town guests to point them out as something out of the ordinary." (Courtesy of Jo Ann Gryder.)

The Yorkville High School band performed at Countryside Center in the mid-1970s. (Courtesy of Jo Ann Gryder.)

Country Charm was a dress shop with mannequins in the windows as well as a restaurant on Route 34 near Tuma Road. Susan Dailey, who grew up in the nearby Fox River Gardens neighborhood, remembers her aunt from New York taking her to Country Charm during visits. "She would come by after school and pick me up, and we would stop at the Country Charm for an early dinner," Dailey wrote. (Courtesy of Jo Ann Gryder.)

Roberta Peterson poses in front of Thomas Pharmacy, on the north side of Route 34 east of Route 47, about 1974. The same building currently houses Duy's Shoes. (Courtesy of Jo Ann Gryder.)

St. Patrick Parish started as a mission church in Somonauk before 1885, when a wooden church building was finished in Bristol, according to St. Patrick Parish communications director Jeanie Mayer. The Yorkville parish center was dedicated at 406 Walnut Street in 1988, and the Eucharist was carried in a procession from the Bristol building to the parish center on Palm Sunday in 2000. Construction started on a new worship space next to the parish center in July 2000, and Rev. Bishop Joseph Imesch designated the 117-year-old mission as an official parish when he dedicated the new building on February 15, 2002. (Both, courtesy of St. Patrick Parish.)

The Fox River bridge on Route 47 was widened from two to four lanes in 1984. Schneider Refrigeration & Appliance and the Yorkville Public Library were torn down to make room for the improvements. (Both, courtesy of the Yorkville Area Chamber of Commerce.)

A group of Bristol-Kendall Fire Department firefighters poses in front of an engine, likely in the 1990s. Pictured, from left to right, are Max Riemenschneider, Verne Riemenschneider, Russell Devick, Tom Lindblom, Harlan Johnson, Jim McCarty, Dave Greiter, Michael Hitzemann, and Ken Johnson. (Courtesy of the Bristol-Kendall Fire Department.)

Dignitaries cut the ribbon at the new Bristol-Kendall Fire Station at 103 East Beaver Street in October 1999. Pictured, from left to right, are trustee Louie Thurow, emergency management service administrator Robert Smith, fire chief Michael Hitzemann, trustee Richard "Shorty" Dickson, and trustee Robert Fisher. (Courtesy of the Bristol-Kendall Fire Department.)

The face of Yorkville's downtown business district continues to evolve. This undated photograph shows a building at the southwest corner of Hydraulic Avenue that has since been replaced by a parking lot, as well as the retaining wall, the sidewalk, and the Muellner Building, which have all been removed at the southwestern corner of Route 47's intersection with Van Emmon Street. (Courtesy of Susan Kritzberg.)

As part of the construction project started in 2013 to widen Route 47 through downtown, the retaining wall and sidewalk were removed from courthouse hill, along with much of the hill itself. Pedestrians along the east side of Route 47 at Van Emmon Street can easily see much of the former Kendall County Courthouse. (Courtesy of the author.)

Pres. George W. Bush is seen here with Dennis Hastert, Speaker of the US House of Representatives, during a visit to the Caterpillar facility in Montgomery on August 10, 2005. Hastert, a former Yorkville High School teacher, was the longest-running Republican Speaker of the House. (Courtesy of Kendall County Republican Women.)

Several members of Kendall County Republican Women enjoy dinner with state representative Patricia Lindner in Springfield. Pictured, from left to right, are Phyllis Oldenburg, Lindner, Jean Hastert, Betty Reese, Carol Liske, Ann Beckley, Peg DeVol, and Connie Peshia. Lindner began representing the 50th District in 1993 and maintained offices in Sugar Grove and Springfield. (Courtesy of Kendall County Republican Women.)

Wrestling is not the only celebrated sport in Yorkville. The 2013 Yorkville High School cross-country teams—both the boys and the girls—won state championships, becoming the third high school in state history to have both genders win the cross-country state championship in the same year. The other two were Winnebago and York. (Courtesy of Songs of Life Photography.)

The 2011 girls' cross-country team won the state championship. The team includes, from left to right, (first row) Casey Kramer, Olivia Reese, and Kelsey Leedy; (second row) assistant coach Ben Draper, head coach Chris Muth, assistant coach Brad Holehan, and assistant coach Rachel Lane; (third row) Esther Bell, Brianna Stuepfert, Ali Hester, Leena Palmer, and Ashley Leonetti. (Courtesy of Songs of Life Photography.)

About 240 Chinese sky lanterns floated over Yorkville on October 6, 2012, and raised about $4,000 for Suicide Prevention Services of Batavia. Organized by Robert Gryder, Jen Slepicka, and the author of this book, the festival invited area residents to light a lantern at Yorkville High School's football stadium at dusk. The lanterns, made mostly of rice paper and a small wax fuel cell, wafted over the Fox River near Heustis Street, and volunteer lantern-chaser Rick Jacobson lost sight of them on Route 71 near Hilltop Road. "The lanterns glowed brightly in our hands as they filled with hot air but in the sky, their light shrunk until they were little dots easily confused with stars," Duchnowski writes in a column for *Yorkville Patch*. "They filled me with childlike wonder." (Both, courtesy of Michalene Bell.)

Almost two centuries after Earl Adams built his cabin just a short walk from the Fox River, fishermen still enjoy fishing from its banks. The Glen D. Palmer Dam, first built in 1952 as part of the Stratton Project Dam System, was converted from an ogee dam to a stepped design starting in 2006. The new design prevented the water from rolling after it flowed over the dam and creating the strong currents that claimed at least two dozen lives over several years. Besides rebuilding the dam, crews also installed the Marge Cline Whitewater Course, providing canoes, kayaks, rafts, and inner tubes two paths around the south side of the dam. On the north side, a Denil fish ladder allows fish to travel both upstream and downstream. A pedestrian bridge connects the park to an island between the whitewater course and the dam. "My son and I love the Bicentennial Riverfront Park," Yorkville resident Jen Slepicka said in 2014. "We have rafted and tubed down the rapids. We picnic there regularly. The soothing sounds and peaceful setting of the riverfront park are a huge reason it is a place that we visit regularly." (Courtesy of the author.)

BIBLIOGRAPHY

Augustine, Shelley. "Remembering Yesterday: Oral History Project at Yorkville Public Library." 2011.
Farber, Jim. "Yorkville's Countryside Center sold." *Beacon-News* (July 11, 2002).
"Foxes win state title!" *Kendall County Record*. (March 4, 1976): 1.
Hastert, Denny. *Speaker: Lessons from Forty Years in Coaching and Politics*. Washington, DC: Regnery Publishing, 2004.
Hicks, Edmund Warne. *History of Kendall County, Illinois, from the Earliest Discoveries to the Present Time*. Aurora, IL: Knickerbocker & Hodder, 1877.
Lord, Steve. "Yorkville movie theatre opens amid fanfare, hope." *Beacon-News* (December 12, 2013).
McCarthy, Jack. "Hastert marks restoration of old courthouse." *Chicago Tribune* (July 5, 2002).
Munson, Richard L. *A Church and its History: Yorkville Congregational Church, 1834–1984*. Yorkville, IL: Kendall County Record, 1984.
"$100,000 Fire at Grade School Thursday Night." *Kendall County Record* (April 6, 1961): 1.
Scott, Tony. "Brutal murders change quiet corner forever." *Ledger-Sentinel* (December 27, 2007): 10–12.
"Spectacular derailment in Yorkville." *Kendall County Record* (July 30, 1970): 3.
Tio, Lucinda and Kathy Farren. *A History of Yorkville, Illinois 1836–1986*. Yorkville, IL: Kendall County Record, and Naperville, IL: Sun Printing, 1986.
"Well Known Yorkville Businessman Succumbs to Illness." *Kendall County Record* (October 23, 1958): 1.

DISCOVER THOUSANDS OF LOCAL HISTORY BOOKS FEATURING MILLIONS OF VINTAGE IMAGES

Arcadia Publishing, the leading local history publisher in the United States, is committed to making history accessible and meaningful through publishing books that celebrate and preserve the heritage of America's people and places.

Find more books like this at
www.arcadiapublishing.com

Search for your hometown history, your old stomping grounds, and even your favorite sports team.

Consistent with our mission to preserve history on a local level, this book was printed in South Carolina on American-made paper and manufactured entirely in the United States. Products carrying the accredited Forest Stewardship Council (FSC) label are printed on 100 percent FSC-certified paper.

MADE IN THE USA